IMAGES
of America

MEMPHIS ZOO

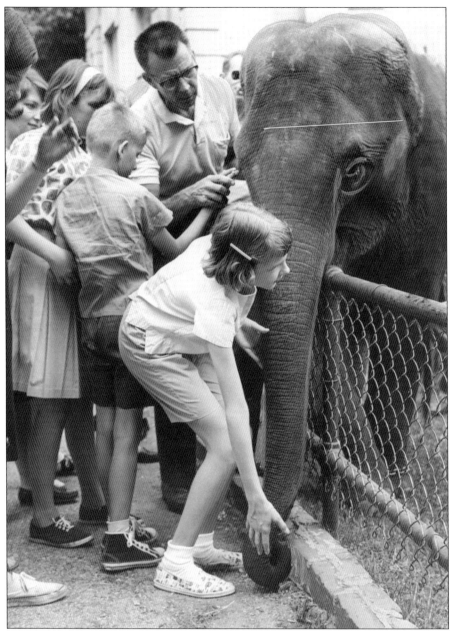

Zoo director Robert Mattlin helps Bobby Scott feel an elephant's eyelashes while Carol Emery touches his long trunk. In July 1965, the Bethel Grove Rainbow Girls sponsored a trip to the zoo for children without sight. After the tour, JoAnne Agell told a reporter, "Before I was just told what everything looked like. Today I could see what the animals looked like with my own hands." (Courtesy of the Mississippi Valley Collection of the University of Memphis Library.)

ON THE COVER: An unseasonably warm weekend brought out zoo-goers in January 1963. Mother and baby elephants were temporarily held in the hippo exhibit, shown here, where they could bond before joining their herd on exhibit. (Courtesy of the Mississippi Valley Collection of the University of Memphis Library.)

IMAGES
of America

MEMPHIS ZOO

Robert W. Dye

ARCADIA
PUBLISHING

Published by Arcadia Publishing
Charleston, South Carolina

Printed in the United States of America

Library of Congress Control Number: 2014954328

For all general information, please contact Arcadia Publishing:
Telephone 843-853-2070
Fax 843-853-0044
E-mail sales@arcadiapublishing.com
For customer service and orders:
Toll-Free 1-888-313-2665

Visit us on the Internet at www.arcadiapublishing.com

*This book is dedicated to those who have given their time, energy,
and resources to making the Memphis Zoo a living treasure.*

CONTENTS

ACKNOWLEDGMENTS

The photographs included in this work come from various collections, and each one provides a unique glimpse into the history of the Memphis Zoo. The staff and volunteers at the Memphis Zoo were most helpful in research and answering my many questions about the zoo's extensive history. I would like to think Ed Frank and his staff at the University of Memphis for their tremendous help. The university's Mississippi Valley Collection contains the zoo-related clippings and photographic files of the *Commercial Appeal* and *Memphis Press-Scimitar* newspapers. The photographers and writers for each of these newspapers documented a time and place in the zoo's history so future authors, historians, and researchers could better understand its roots and the people who shaped its future. The Memphis Room of the Memphis and Shelby County Public Library was very helpful with research concerning the Memphis Park Commission and the zoo. Wayne Dowdy and his knowledgeable staff helped dig through 108 years of zoo history collected over the years by the library's archivists. Images were also generously loaned from the following individuals and institutions: Ray Brown, Donne Walden, Earnestine L. Jenkins, Joe Bennett, Detroit Publishing Company, Tennessee State Archives, and the Library of Congress. I would like to thank Emily McMackin for her writing, editing, and support throughout the course of this project. I would also like to thank all the writers and photographers—both known and unknown—who documented the Memphis Zoo through the years. It is because of them that we have a vivid portrait of the animals and the people who have made the zoo the outstanding institution it is today—not only for the city of Memphis, but also as a worldwide model of what can be accomplished through hard work, dedication, and a love of animals. Unless otherwise noted, all images appear courtesy of the Mississippi Valley Collection of the University of Memphis Library.

INTRODUCTION

He knew the vote would be close, having failed just four months earlier to receive another vote besides his own. Now, Robert Galloway would make the motion again, this time with a petition signed by over 2,000 Memphians. This time, the Memphis Parks Commission, by a 2-1 vote on April 4, 1906, established an annual fund of $1,200 to be used for the purpose of creating a zoo for the city of Memphis.

The idea of a zoo, or menagerie as they were called in the early 1900s, dates back to the early Egyptians. Queen Hatshepsut sponsored expeditions into Africa to collect giraffes and cheetahs around 1400 BCE. Until the 19th century, animals for display and study were only for the nobility. The London Zoological Park originated in 1828 for the purpose of scientific studies and opened to the public in 1847. Its aquarium, dating to 1853, is the oldest in the world. American zoos began with the Philadelphia Zoo in 1874, followed by the Cincinnati Zoo in 1875. By 1940, over 100 American cities had zoos. Zoos set themselves apart from menageries and traveling animal shows by stating their mission as education and the advancement of science and conservation. Most American zoos were founded as divisions of public parks departments. Having a zoo symbolized progressiveness, and it reflected to the rest of the country a level of cultural accomplishment on par with the largest cities. As Memphis mayor J.J. Williams stated to the director of the National Zoo in 1901, "Memphis has not yet progressed sufficiently to have a collection of animals in its Park. We hope, however, for this at no distant day."

In 1901, the city formed the Memphis Park Commission, headed by John R. Goodwin, L.B. McFarland, and Robert Galloway. One of the first orders of business was to obtain 375 acres of land on the outskirts of Memphis from Overton Lea of Nashville for the purpose of creating a park. The final price came to $110,000. Landscape architect George Kessler was hired to convert the land into a park the citizens of Memphis could enjoy for years to come. Overton Park, named for Memphis founder John Overton, officially opened in 1906.

Just how Natch, the zoo's patriarch bear, got to Memphis is still a source of speculation. Some say he came up the Mississippi River with a baseball team from Natchez, Mississippi. The team returned to Natchez but left its ever-growing and mischievous mascot behind. Another version has him being given to Robert Galloway in lieu of payment for business items. However Natch made his way to Memphis, he soon became a celebrity. The Memphis Turtles baseball team took him as its mascot until he became too large and aggressive. The solution was to tie him to a tree in Overton Park. Eventually fenced in and fed by visitors to the park, he became a bear without a home, forced to live off the generosity of others. Over time, citizens donated other animals to the park, including a wildcat and a monkey to keep Natch company. It was about this time that Robert Galloway began his campaign for a zoo in Overton Park. The first vote, in November 1905, failed to pass, because the other commissioners felt the city did not have the money to adequately fund a zoo and were unsure if the citizens would support such an enterprise. Yet throughout the Memphis Zoo's first century, it has been the citizens who have stepped in and given their

time and money to keep it moving forward. There were many donations of animals, including monkeys, rabbits, and birds from local citizens. An elephant was obtained in 1906. Pawnee Bill's circus visited Memphis and left behind a baby camel christened Al Chymia in 1908. A mate for Al was purchased in 1909, and in 1910, a baby camel was born. All animals were housed in Galloway Hall until the bear dens were built in 1910. On December 29, 1910, the first meeting of the Memphis Zoological Society was held at the residence of Henry Loeb, for the purpose of supporting a zoo. In his standard *History of Memphis*, published in 1912, Judge J.P. Young lists one of the chief attractions of Memphis as "the splendid zoological garden in the forest with 405 selected animals, birds and reptiles installed in their buildings, dens etc, at a cost of $31,726.58." In 1915, Robert Galloway brought three large alligators home from Florida, and in 1909, a traveling medicine show donated its star attraction, a brown bear named Ruco.

The first Memphis Zoological Society was formed in 1910, supporting the zoo through its infancy. Memphis stood second in attendance among free zoos in the country in 1917. After 1920, the inertia of public interest began to drop. Memphis moved from second to fifth place among zoos, animals needed more attention, and the zoo that had started with such enthusiasm needed help. On February 6, 1923, a meeting was organized by the Memphis Chamber of Commerce to discuss the matter. Henry C. Muskopf, secretary for the St. Louis Zoological Society, spoke on how the society's 3,000 members worked together to build their zoo into one of the best in the nation. Soon after, the chamber elected a board of directors, with Henry Loeb as president. Loeb had earlier helped obtain hippos Venus and Adonis through a citywide fund drive in 1914. Annual dues for the zoological society were $10, with $200 allowing a citizen to be a life member. The first life member was Ramelle Van Vleet, who in 1936 donated a pair of Italian marble lions to the zoo, which graced its entrance for over half a century.

It was in 1923 that a young man named Nicholas J. Melroy was hired as superintendent, after having worked winters at the Memphis Zoo while his traveling animal show was on break. Tattoos covered his body from his days with the Ringling Bros. and Barnum & Bailey Circus. He knew how to do two things the Memphis Zoo desperately needed—draw a crowd and care for animals. His relationship with the zoo would last 30 years, longer than any other superintendent or director. He established a small, one-ring circus, obtained financial assistance from local and federal lawmakers, and used his contacts in the animal world to obtain lions, tigers, and other exotic animals. More than anything, he kept the zoo moving forward during times when most of the country was out of work or at war. He was resourceful and put the animals' well-being above all else.

In the 1930s, with the help of the Works Progress Administration, the zoo grew with numerous additions, including Monkey Island, a moat for the elephant house, barless bear pits, an aviary, and larger pens for many of the zoo's hoofed animals. The stork had a banner year at the zoo in 1936, increasing its animal population to over 1,500 animals for the first time in the young zoo's 28-year history. In 1937, a booklet stated, "The advertising afforded Memphis by is Zoological garden is invaluable to the convention city, and the attendance and interest shown in the garden have been gratifying." Kiddie Land, part amusement park and part petting zoo, opened in 1943 and became a Memphis tradition for the next 60 years. Many Memphis children had their first pony ride at the kiddie zoo. A day at the Memphis Zoo for a child was a day for his or her senses to revel in all the zoo had to offer. Children admired the peacocks calling out to their mates while showing off their colorful plumage. They shuddered at the roar of the lions echoing through the Carnivora building like the beginning of a classic MGM movie. They delighted in the feel of a sheep's thick, coarse wool or the texture of a snake as it slithered across their arms. They marveled at the sight of a 3,000-pound hippopotamus gracefully gliding into the water and breathed in the smell of an elephant as it threw dust over its massive back. Nowhere else in the area could a child see, hear, feel, taste, or smell so much in one day.

Beginning in 1953, the Memphis Zoo began a 10-year rebuilding program that included renovation of almost every exhibit on the 40-acre property. The only buildings not affected were the 1909 Carnivora and Pachyderm buildings. During the 1960s, the expansion of the zoo was put on hold until the Supreme Court ruled against a proposed routing of Interstate 40 through Overton Park.

Once the zoo officials knew it was safe, they began to expand eastward with the African Veldt and new exhibit spaces for the elephants and rhinos, enlarging the zoo to 70 acres.

"Eventually, we plan to have practically every animal in the zoo—including the tigers and lions—behind moats, but that will take a lot of time and a lot of money," said Joe Brennan, chairman of the Memphis Park Commission in 1938. It would take 55 years for Brennan's dream to come true. During the 1930s, there were many improvements to the zoo, including cageless exhibits for the elephants, monkeys, and bears, but not for the large cats. The Memphis Zoo's lions and tigers lived behind bars in the Carnivora house for 84 years. In 1993, after a $30 million building campaign, the cats finally felt grass under their paws for the first time, in a four-acre complex. Cat Country allowed visitors to see a mix of 10 species of cats, seven species of prey animals, an Egyptian temple, remnants of an ancient Asian city, caves, rock outcroppings, grassy savannahs, and waterfalls. Seven species of cats exhibited are considered endangered.

Following the success of Cat Country, the zoo turned its attention to the primates. In what zoo officials called the most important year at the zoo, Primate Canyon, Once Upon a Farm, and Animals of the Night opened to the public. Completed in 1995, Primate Canyon, offered 10 species of apes and monkeys a natural habitat that included trees, waterfalls, rock outcroppings, grass, and climbing structures for them to enjoy. The five-acre exhibit, created by Design Consortium of New Orleans, contained seven exhibits with multilevel viewing areas for the guests. Once Upon a Farm allowed kids to experience life on a 19th-century farm. Animals included ducks, chickens, sheep, horses, and a miniature cow. The Animals of the Night exhibit also opened in 1995 in the former primate house. Here, zoo-goers can learn about the lives of nocturnal animals such as bats, aardvarks, springhaas, and even naked mole rats. Begun in 1997, Butterflies: in Living Color allowed visitors to walk among 10,000 free-flying butterflies. In 2009, this exhibit was transformed into the Birds and Bees exhibit, which allowed guests to walk among 500 free-flying parakeets and even feed them from handheld seed sticks. They could also watch a large hive of honeybees behind protective glass.

In the summer of 2002, the zoo opened one of its most anticipated exhibits: China. The exhibit displays Asian animals such as Père David deer, white-naped cranes, otters, and white-cheeked gibbons. But the stars of the exhibit are two giant pandas, Le Le and Ya Ya, who were brought from China though a partnership with the Chinese government. With the addition of giant pandas, Memphis joined zoos in San Diego, Atlanta, and Washington, DC, in research and captive breeding programs for this critically endangered species. The Northwest Passage exhibit opened in March 2006 and showcases animals from the Pacific Northwest, including polar bears, bald eagles, and black bears. Constructed at a cost $23 million dollars and covering over three acres, the exhibit includes large viewing windows set below the water level for guests to watch polar bears and sea lions swim in 500,000 gallons of purified fresh and salt water. The exhibit also includes a 500-seat amphitheater used for sea lion shows. In 2009, the $16 million dollar Teton Trek exhibit opened exploring the rich history, culture, and wildlife of the Yellowstone area. Animals include grizzly bears, elk, and gray wolves. The exhibit was made possible by a generous $10 million donation from Fred and Diane Smith. Opening in 2016 will be the Zambezi River Hippo Camp. Zoo-goers will be able to see hippos on land and in the water through large glass viewing windows. Other animals will include Nile crocodiles, okapi, and flamingos. Splish, the granddaughter of the zoos first hippos, Venus and Adonis, will make the exhibit her new home.

The spot where Natch was left abandoned is today commemorated by a marker just outside the Pachyderm building, now a library and research archives for the zoo. What started with an orphaned bear tied to a tree is today one of the top zoos in the nation. Attracting more than one million visitors a year, the zoo is recognized nationally not only as a tourist attraction but also for its animal research, breeding programs, and reintroduction studies. The Memphis Zoo has overcome numerous obstacles over the years. Often working with limited funds, the zoo enjoys continued success due to the creativity and determination of staff and volunteers who have over the years put the welfare of the animals above all else. As longtime director N. J. Melroy once said, "These animals are like my children, every day that I come to the zoo I say, 'Daddy's home.'"

One

NATCH FINDS A HOME

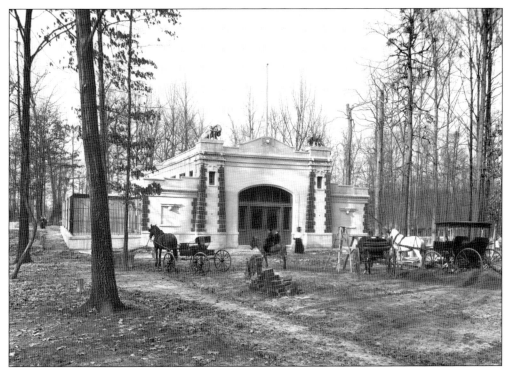

The Carnivora building, shown just after completion in 1909, was the centerpiece of the zoo for many years. For visitors entering the zoo, it was the first major building they would see, its white facade glowing in the midday sun.

Natch the bear, shown in Overton Park around 1905, was the impetus for the creation of the Memphis Zoo. Abandoned and chained to a tree in Overton Park, the bear and his plight inspired the Memphis Park Commission and the citizens of Memphis to create a better home for Natch as well as for other animals left at the park with him.

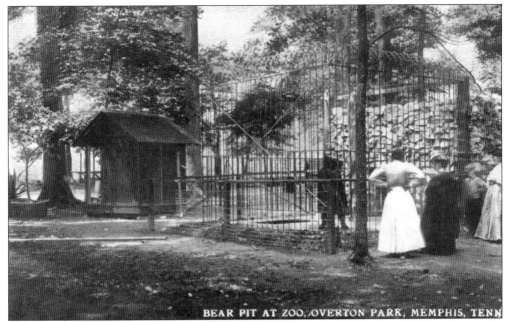

BEAR PIT AT ZOO, OVERTON PARK, MEMPHIS, TENN

In 1908, three black bears were given to J.T. Willingham of the Memphis Park Commission by friends in Mississippi. Citizens wanted to be a part of the zoo and help in any way they could. It was not uncommon for a commercial fisherman who found himself with a large snapping turtle or a farmer who trapped a fox, for example, to contact the zoo to see if it was interested in a donation. (Courtesy of Ray Brown.)

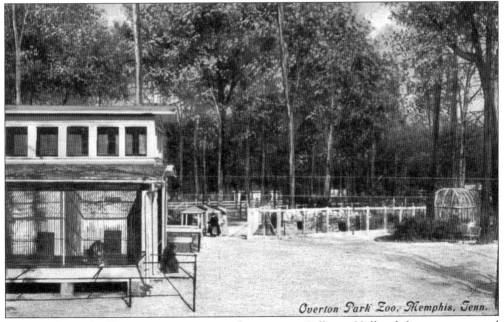

Overton Park Zoo, Memphis, Tenn.

By 1908, the zoo had begun to grow in size and reputation. Galloway Hall, at left, was constructed and held most of the zoo's menagerie, including lions, tigers, and monkeys. Outdoor pens held elk, deer, bison, and a Bactrian camel donated by the Al Chymia Shriners of Memphis. (Courtesy of Ray Brown.)

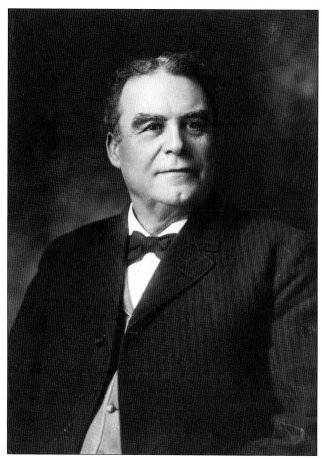

Robert Galloway was the early catalyst for the formation of the Memphis Zoo. Born in 1843, Galloway came to Memphis after the Civil War and eventually became president of the Galloway Coal Company and the Patterson Transfer Company. He was a founding member of the Memphis Park Commission and spent much of his own money helping to create the foundation for the world-class zoo Memphis has today. He lived a block west of the zoo at Paisley Hall, a house on Overton Park Drive that still stands today.

The Memphis Zoo, long known as the Overton Park Zoo, was carved out of a virgin forest filled with oak, sycamore, ash, and tulip poplar trees. This view looking toward the zoo's greenhouse, built in 1916, offers a glimpse of the wooded area the zoo was constructed around. By incorporating the natural canopy of the mature trees into its design, the zoo was cooler in the hot summer months, not only for the guests, but also for the animals.

In 1909, the zoo purchased its first polar bears, a female named Ella and her mate. Ella lived until 1937, just before the completion of the new bear moats. By 1916, the Memphis Zoo had grown to include over 700 animals, including four lions, two hippos, two polar bears, and six ostriches. Other unusual animals included 100 South American guinea pigs, eight squirrels, three turkeys, and ten white rats. (Courtesy of the Memphis Public Library.)

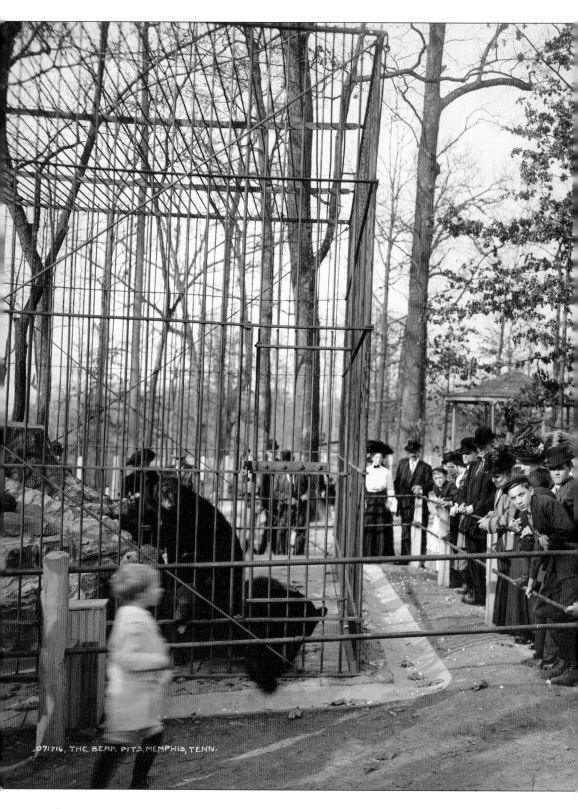

071716, THE BEAR PITS, MEMPHIS, TENN.

16

By 1910, the Memphis Zoo had grown to include more than 42 separate exhibits ranging from elephants to rabbits. Shown here are three young black bears donated to the zoo by J.T. Willingham, a commissioner of the Memphis Park Commission and a zoo worker. The bears were fed beef and fresh bread once a day. Today, American black bears live in 40 of the 50 states, and they number around 300,000 in the United States alone.

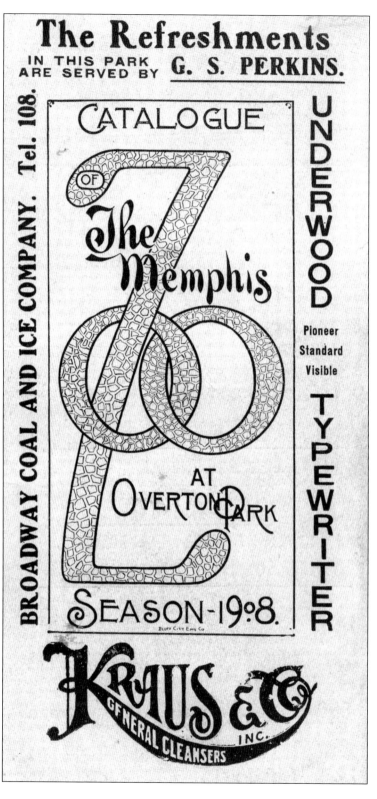

In 1908, the young zoo needed to let the city know all it had to offer. Its catalogue states, "Since the inception of the zoo which is fast becoming a feature of Memphis' advance toward metropolitism, never has its permanency and future development been as certain as the advent of season of 1908." The promotional catalogue names each animal, where it came from, and how the zoo came to acquire it. The cover sponsor of the catalogue, Memphis-based Kraus & Co., was an early supporter of the zoo and is still in business today.

18

By 1910, the zoo became a social destination for many Memphians. Citizens came by trolley or horse-drawn carriage to see the animals, admire the landscaping, and enjoy Overton Park. (Courtesy of the Memphis Public Library.)

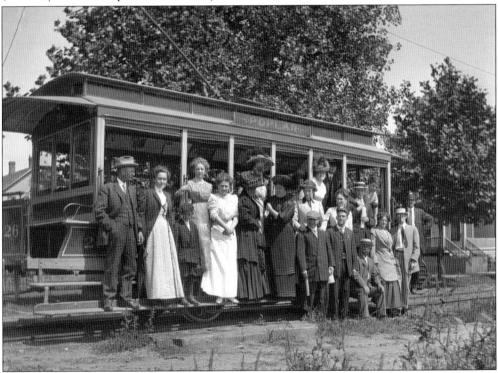

Before the widespread use of automobiles, the Memphis Street Railway Company operated 77 miles of track in Memphis, with 310 cars. Shown here around 1911, the Poplar Street line connected downtown Memphis with Overton Park and the zoo. A one-way ticket to the zoo from downtown cost 9¢ in 1911.

The early days of the zoo allowed close contact with many of the animals. Baby animals have always been a draw for any zoo, and attendance typically jumps up when a zoo has a baby panda or a polar bear with twins.

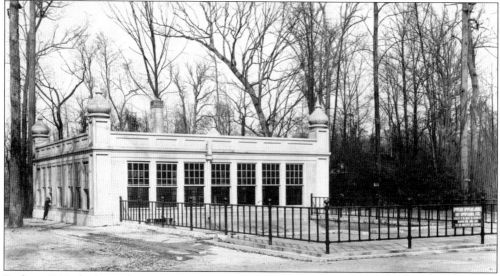

Built in 1916, the hippo house was home to Venus and Adonis for many years. The white marble structure included indoor and outdoor pools and a private birthing room. The outdoor pools from the original structure remained even after the building was torn down in 1955 to make way for a new, more modern habitat for the hippos. Adonis fathered 16 calves by Venus and 10 additional calves by two other females. Adonis lived until 1965, passing away at the age of 54. At the time, he was the world's oldest known hippopotamus.

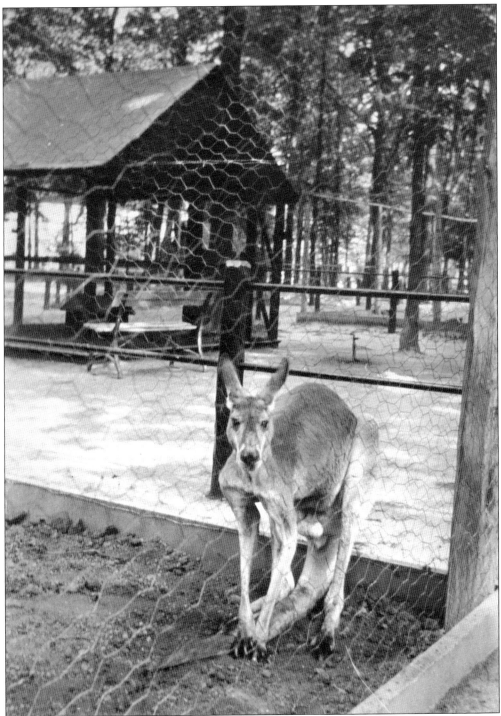

Kangaroos were first exhibited at the Memphis Zoo around 1910. There are more than 50 species of the marsupials that call Australia home. The largest is the red kangaroo, reaching a height of more than six feet and weighing 200 pounds. They can leap 10 feet high and cover over 30 feet in a single bound. (Courtesy of the Memphis Public Library.)

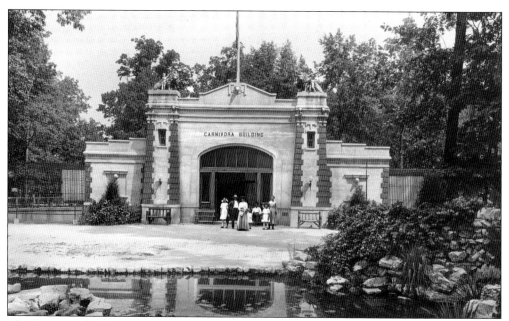

The Carnivora building, designed by L.M. Weathers in 1909, is the oldest building at the Memphis Zoo. The lion statues gracing the front are cut from limestone, and an observant eye will notice that they were switched when the building was renovated in 1990. The building housed various lions, tigers, and other cats until it was retrofitted into a restaurant, the Cat House Café, in 1990. Today, the animals enjoy lush, state-of-the-art surroundings in the Cat Country exhibit nearby.

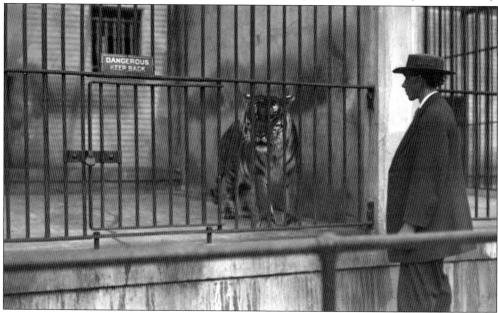

Wynne Cullen, who took over the role of superintendent of the zoo after E.K. Reitmeyer, stands with a tiger at the Carnivora building around 1913. The first tiger at the zoo was a Bengal tiger called Samantha, named by the schoolchildren of Memphis. She was purchased from Ringling Bros. and Barnum & Bailey Circus for $500 and fed 15 pounds of beef and one pint of sweet milk daily.

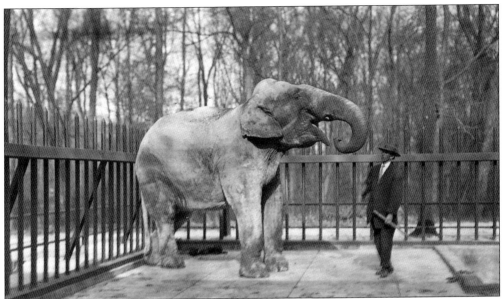

Due to their sheer size, elephants have long held a fascination for zoo-goers. Superintendent Wynne Cullen is shown training one of the early Asian elephants at the zoo, around 1912. The first elephant at the zoo was a female African elephant named Margarite, purchased by Robert Galloway and J.T. Willingham for $1,700 from the Ringling Bros. and Barnum & Bailey Circus in 1907. She was named by the schoolchildren of Memphis in a contest sponsored by the *Commercial Appeal* newspaper.

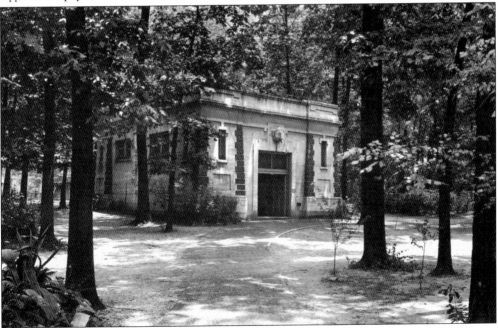

The Pachyderm building was designed by Memphis architect L.M. Weathers and built in 1909. A moat was added in 1936 to give visitors an unobstructed view of the largest mammals on earth. Home to African and Asian elephants until 1970, the building is today used as a library and research center for zoo staff. (Courtesy of the Memphis Public Library.)

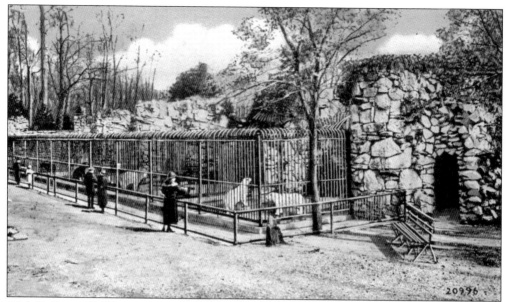

With Galloway Hall becoming too small for the ever-growing collection of animals, a large multi-pen enclosure was built for the bears around 1913. This gave the animals more freedom to move, but it would still be more than 30 years before patrons would be able to see the majestic animals without looking through iron bars. (Courtesy of Ray Brown.)

Animals at the Zoo, Overton Park, MEMPHIS, TENN.

A 1912 postcard shows some of the zoo's most popular animals, including Dwyer the African lion, an African leopard purchased from Horns Zoological Arena in Denver, Colorado, and buffalo purchased from the Cincinnati Zoo. German animal trader Carl Hagenbeck used the Cincinnati Zoo to hold many of the animals he brought to the United States for future sale. Many of the Memphis Zoo's early animals came from the Cincinnati Zoo and were acquired through Hagenbeck. (Courtesy of Ray Brown.)

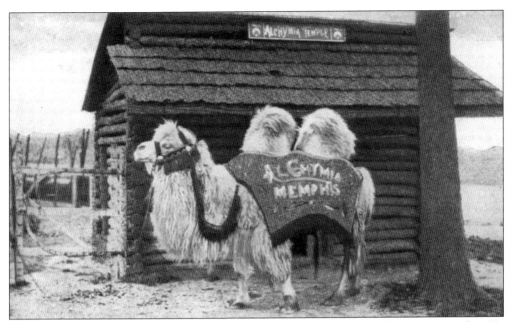

Al, as he was known by zoo-goers, was the mascot for the Al Chymia Shrine in Memphis. He was donated to the shrine by Pawnee Bill, a Wild West performer and showman. Once, while in a Shriner parade, Al decided sit in the middle of the street, because the pavement was hurting his feet. Unable to move the camel, officials had the parade routed around him. He was later fitted with special shoes to cushion his walk during parades. (Courtesy of Ray Brown.)

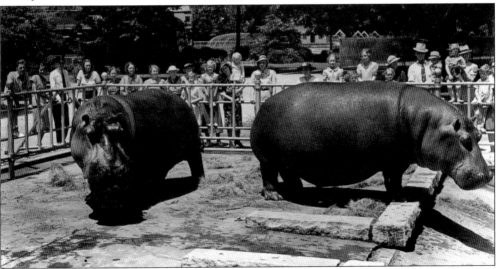

Local citizens and businesses donated many of the early animals at the zoo. Others were purchased from animal traders who traveled around the world collecting animals for circuses and zoos. The largest dealer in the late 19th and early 20th century was Carl Hagenbeck, a native of Hamburg, Germany. It was from Hagenbeck in 1914 that the zoo purchased two hippopotamuses, Venus and Adonis, shown here in the 1940s. A parade was held when the animals were delivered to the zoo. Memphians lined the streets as large trucks slowly carried the new arrivals from downtown to their new home at the zoo. Schools even let students out of classes to greet the zoo's new larger-than-life celebrities as they passed by. (Courtesy of the Tennessee State Archives.)

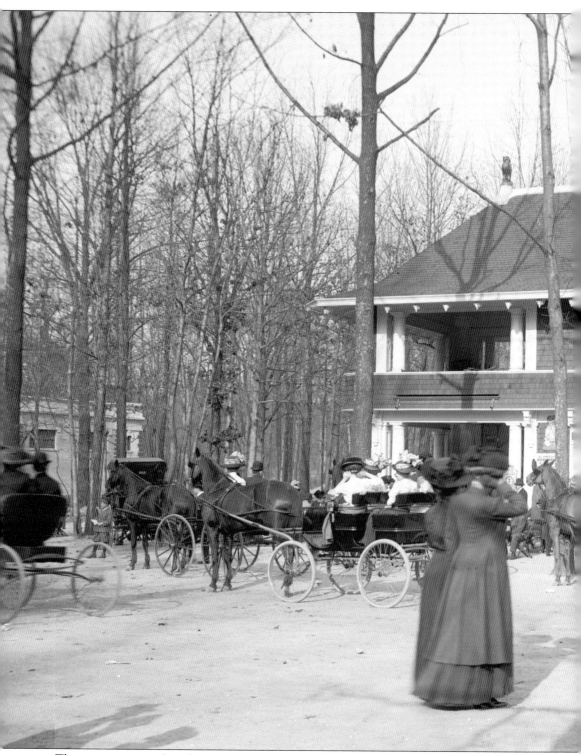

The concession pavilion, located just outside the zoo, was built in 1908 to attract more people to the newly created Overton Park and the zoo. Concerts and dances were held at the open-air

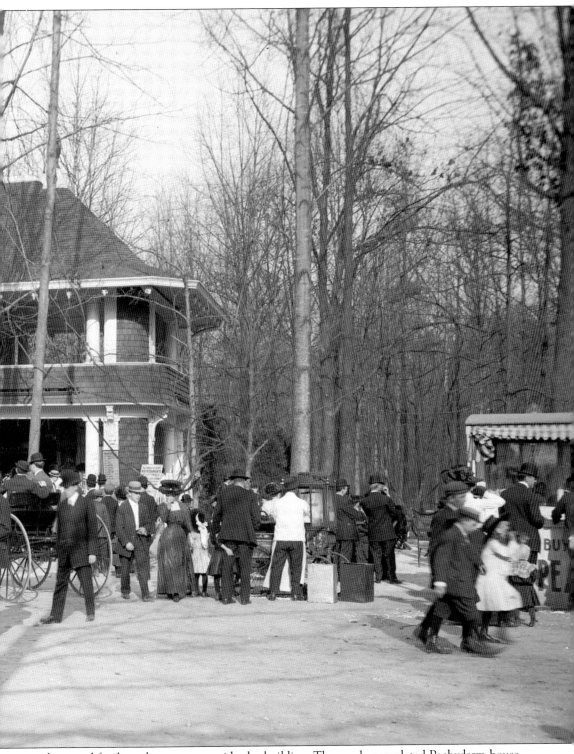

pavilion, and food vendors set up outside the building. The newly completed Pachyderm house can be seen on the far left.

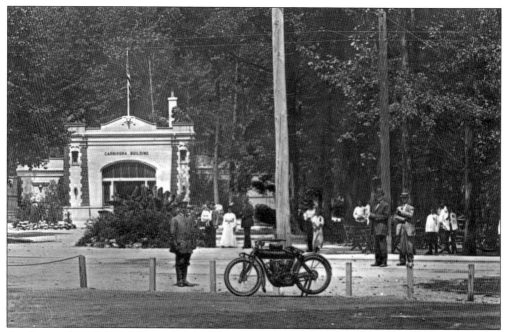

A rider stands with his 1909 five-horsepower Indian motorcycle in front of the Carnivora building around 1910. Today, that rider would be standing at the zoo's main entrance, refurbished in 1993 with an Egyptian theme. Musicians can be seen to the right with chairs set out for a concert.

This view toward the zoo's greenhouse, built in 1916, shows how the zoo was planned around the natural environment. The zoo is listed today as an arboretum, with over 50 species of mature trees. Without the modern convenience of air-conditioning being available in homes or office buildings until the 1950s, people would spend more time outside in parks, especially during the warm Memphis summers.

Because the zoo was situated in the lowest section of Overton Park, the threat of flooding was always a concern. In the fall of 1906, a hurricane hit the Gulf Coast and made its way slowly toward Memphis. The headline in the *Commercial Appeal* newspaper on September 29, 1906, reads, "Infant Zoo is threatened with Complete Annihilation." Lick Creek, which runs on the east side of the zoo, had flooded due to the heavy rains. Water was knee-deep, with many animals lying in mud and others becoming sick, including Natch the bear.

In 1908, the zoo had a cinnamon bear, named Teddy after Pres. Theodore Roosevelt. Teddy was purchased by J.T. Willingham from Horn's Zoological Park Arena in Denver, Colorado, to join two black bears donated by friends of the zoo. By 1923, the zoo's bear population had increased to 11 bears, including three polar bears, two grizzly bears, and a Russian bear.

Built in 1916 as a working greenhouse for the Memphis park system, the greenhouse at the Memphis Zoo was used for botanical displays before tropical bird exhibits were added in the 1920s. By the 1950s, it showcased snakes before being converted to its present use as a tropical bird exhibit. Today, the building presents more than 60 species of birds in a naturalistic habitat created after an extensive restoration of the structure in 1988. (Courtesy of the Memphis Public Library.)

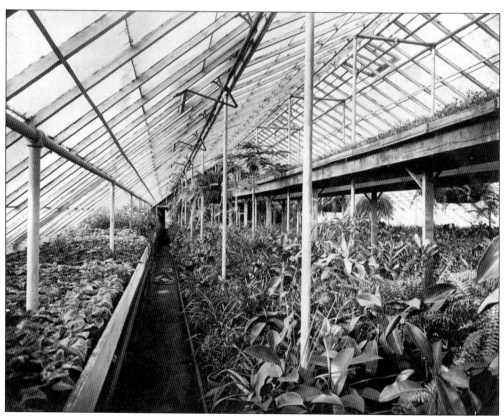

The greenhouse at the zoo not only produced plants for landscaping, it also provided the city's many parks, hospitals, and schools with tropical flowers and shrubbery. Additionally, a 51-acre nursery off-site provided the zoo with much-needed food for the animals, including 923 bales of hay, 207 bushels of carrots, 954 heads of cabbage, and 102 bushels of sunflower seeds in 1914 alone. (Courtesy of the Tennessee State Archives.)

Two

MELROY TALKS TO THE ANIMALS

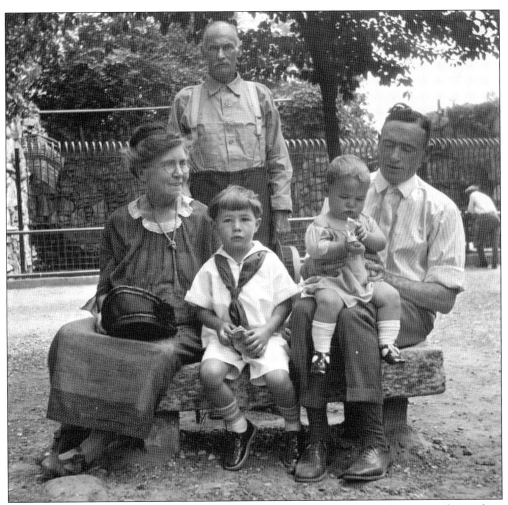

The zoo has always been a place for families to visit, for parents and grandparents to bring their children. Here, the author's father, Robert Dye (center wearing a sailor suit), is joined by younger brother Lorell, father, Jesse, and grandparents William Wesley and Lucy in front of the bear pens in 1924. In a time before television, iPads, and video games, children could engage their imaginations and marvel at animals they had only read about in books such as the Edgar Rice Burroughs classic *Tarzan of the Apes*. (Courtesy of the Dye Collection.)

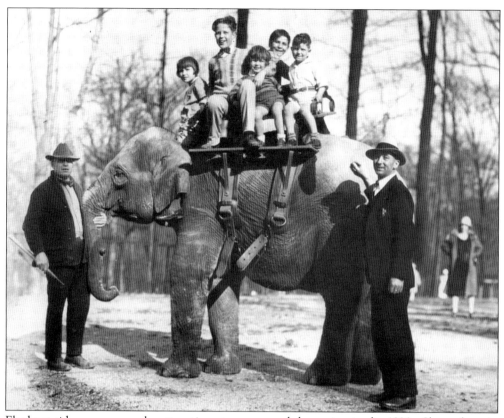

Elephant rides were a popular attraction at zoos around the nation in the 1920s. Shown here in 1929, zoo superintendent Nicholas J. Melroy (far right) oversees an elephant ride at the Memphis Zoo. Asian elephants, like the one pictured here, are more easily trained than their African counterparts. Many of the zoo's early elephants were purchased or donated from circuses as the elephants aged or were retired.

Among the 1,115 animals listed on the 1923 census of the Memphis Zoo were two "African zebras." Several species of zebra are currently listed as endangered, including the Cape Mountain and Grévy's zebras. The animals are actually black with white stripes, which serve several purposes, including camouflage, identification among other zebras, and even repelling flies. Today, Grant's zebras are showcased in the African Veldt exhibit area of the Memphis Zoo. (Courtesy of the Memphis Public Library.)

Built in 1907 to house a majority of the zoo's animals, Galloway Hall later served the zoo as a reptile house until it was demolished in 1954. Named for Robert Galloway of the Memphis Park Commission, the first structure at the zoo was briefly home to hippos Venus and Adonis as well as lions, tigers, and even an elephant.

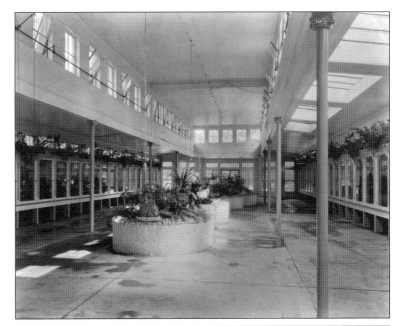

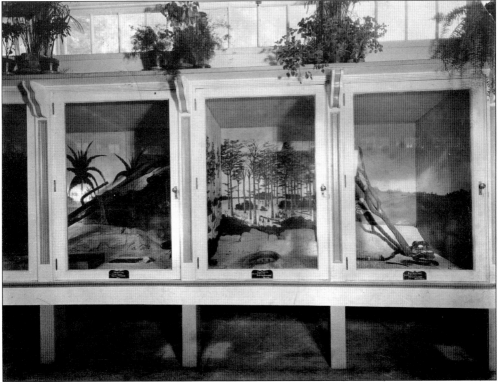

Most zoos began with animals native to their locale. The Memphis Zoo was no exception, displaying raccoons, opossums, white-tailed deer, and rattlesnakes. The snakes were kept in Galloway Hall with cages painted to resemble their natural habitats. A 1908 brochure describes a "cage holding three vicious diamondback rattlesnakes, the most poisonous of the snake family, donated to the zoo by friends in Mississippi."

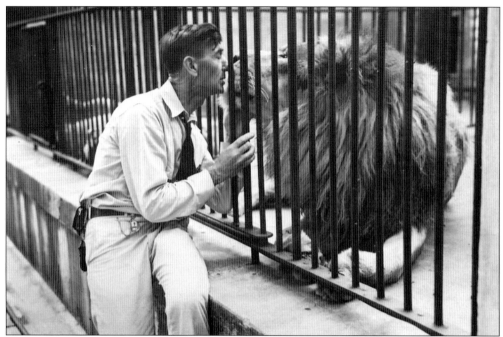

N.J. Melroy, or "Mel" as he was known to everyone at the zoo, began his lifelong career with animals by working with the great traveling circuses of the day, including the Ringling Bros. and Barnum & Bailey as well as the Hagenbeck-Wallace shows. From 1916 until 1923, he operated his own circus, Melroy's Wild Animal Show. "He was probably the last of the great circus men who became zoo directors," said Raymond Gray, who replaced Melroy as zoo director in 1953. (Courtesy of the Tennessee State Archives.)

Howard and Elsie Boaz pose for the camera at East End Park. A day at the zoo often included a trip to the nearby park, located south of the zoo just across Poplar Avenue. The entertainment facility contained a roller coaster, dance hall, vaudeville performances, swimming pool, and roller-skating rink. Established in 1889, the park was active in one form or another until the early 1930s.

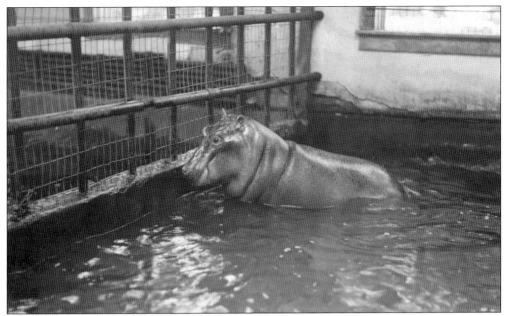

The zoo's celebrity hippos Venus and Adonis sired eight babies in their first 20 years at the zoo. One of their many offspring, shown here in 1920, enjoys a dip in the indoor pool. In 1935, Venus and Adonis became grandparents when their calves Bebe and Toto, who were sold to the Chicago Zoo in 1933, gave birth to a 50-pound bundle of joy. It takes up to a year to determine the sex of a hippopotamus.

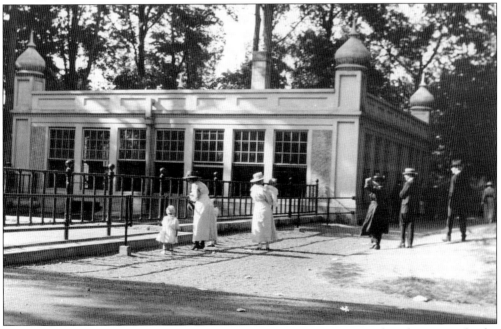

Henry Loeb, president of the Memphis Zoological Society in 1923, carried on the passion for the zoo after the passing of Robert Galloway in 1918. With support from Memphis schoolchildren, he helped raise $4,000 in 1914 to bring hippos Venus and Adonis to Memphis. The hippos first resided in Galloway Hall, before being moved into their own quarters (pictured) in 1916.

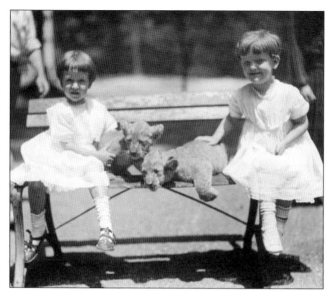

A day at the zoo in 1920 for these girls meant the opportunity to pet two cuddly lion cubs. As is still practiced today, animals that were tame enough were brought out for the public to see and touch. Polly, the first lioness at the zoo, was donated by the Hoadley Ice Cream Company of Memphis, in 1907. In 1908, Polly gave birth to a pair of cubs, the first birth of a carnivore at the zoo. According to a 1908 brochure on the zoo, "Polly devours fifteen pounds of meat and drinks one pint of sweet milk each day."

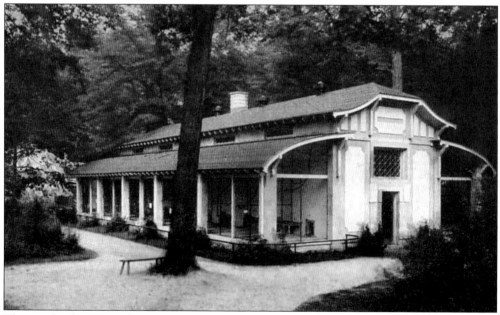

The monkey house was built in the 1920s to house many of the zoo's smaller apes and monkeys. In 1908, the zoo had six Madagascar monkeys purchased from Carl Hagenbeck through the Cincinnati Zoo. The zoo also had four spider monkeys and one Java macaque monkey named Miss Koozie. Purchased from W.C. Ward of Memphis, Miss Koozie enjoyed a diet of carrots, onions, and sweet potatoes.

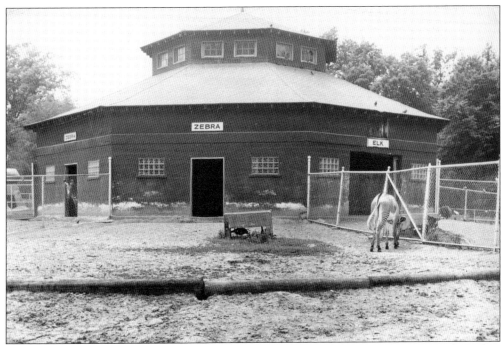

The round barn, as it is still known today, originally served as the stables for the Memphis Police Department's mounted patrol. It was moved to the zoo in 1923 and used to exhibit hoofed animals, including camels, zebras, and elk. The stone facades and interior walls were added in the 1950s.

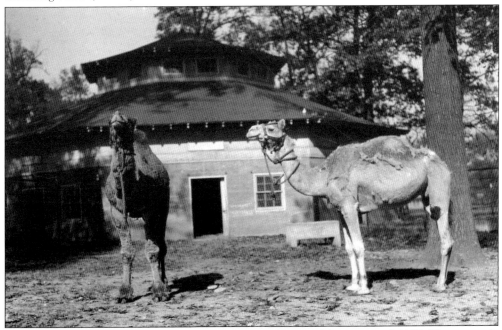

Two Arabian, or dromedary, camels are shown at the round barn around 1927. These camels were first domesticated more than 4,000 years ago and are today found in Africa, India, and the Middle East, numbering more than 15 million. In 1922, the zoo had two Arabian camels and one Bactrian camel.

N.J. Melroy came to the Memphis Zoo in 1923 after spending his early life traveling the carnival circuit. His full body tattoos hinted to earlier days when he was billed as the "Illustrated Man." Often, military servicemen would show up at the zoo asking for "the guy who does the great tattoos." Now, he had a more settled life, overseeing 1,200 animals who depended on him for their survival. For over 30 years, he kept the zoo going, many times making do and holding it together with little money from the city. During the Great Depression, he would visit restaurants for scraps of meat to feed the lions. During World War II, he grew a victory garden at the zoo to help feed the animals. He would take in orphaned animals and care for them in his home until they were strong enough to return to the zoo. He had a special bond with the animals—a relationship that could only be gained through years of interaction and trust.

The steel and concrete aviary at the zoo was completed in 1937 at a cost of $4,500 and stood 40 feet tall and 70 feet long. The first occupants were bald eagles, black vultures, and a lone giant condor. A smaller enclosed area circled the aviary and contained cages for pheasants and Japanese Silkie chickens. (Courtesy of the Memphis Public Library.)

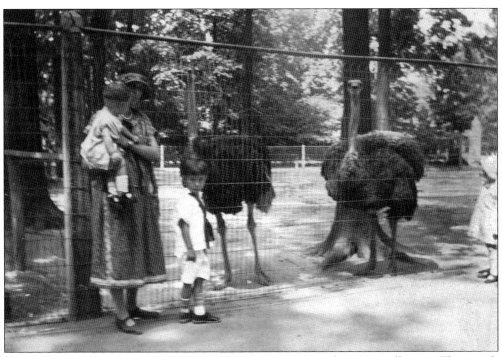

By 1924, the zoo had six ostriches, along with two emus and one rhea in its collection. The ostrich can reach speeds of 40 miles per hour on the ground, weighs up to 300 pounds, and stands up to 9 feet tall. Known for their exotic plumage, ostriches lay the largest egg of any living bird species, with eggs weighing an average of three pounds each. (Courtesy of the Dye Collection.)

PROGRAM
Dedication Ceremonies

MONKEY ISLAND
MEMPHIS ZOOLOGICAL GARDEN
OVERTON PARK
MEMPHIS, TENNESSEE

•

DEDICATED TO THE PEOPLE OF MEMPHIS FOR THEIR
EDUCATION, PLEASURE AND RECREATION
SUNDAY, SEPTEMBER 13, 1936
AT 3 P. M.

Built through the cooperation of
W. P. A., MEMPHIS PARK COMMISSION
AND THE CITY OF MEMPHIS

During the dedication for the opening of Monkey Island, bands performed, speeches were given, and 7,000 bags of peanuts were distributed to children in attendance. But the true entertainment was on the island, where lighthearted monkeys played for the crowd.

Ask most Memphians what their favorite part of the old zoo was, and most will say Monkey Island. Built as a WPA project in 1936 for $14,764, Monkey Island was home to the zoo's rhesus monkeys for more than 60 years. More than 25,000 people attended the dedication of the new exhibit on September 13, 1936.

People would stand for hours just to see what crazy antics the monkeys on Monkey Island would get themselves into. Some would swim out into the moat to collect peanuts thrown by visitors, while others would swing on a giant wheel or slide down a chute in groups. (Courtesy of the Dye Collection.)

Construction of the zoo's bear pits began in November 1937, with the dedication on July 31, 1938. The WPA zoo project also created Monkey Island, a moat for elephants Florence and Alice, a large steel aviary, and new space for the zoo's elk, deer, camels, and buffalo. The bear pits were demolished in 2014 to make way for the Zambezi River Hippo Camp.

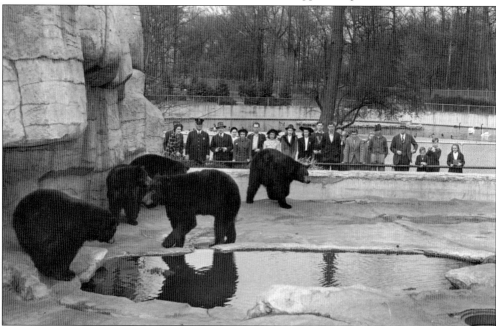

Zoo visitors get an open look at a group, or sloth, of brown bears in 1941. Built in 1938, the bear pits allowed an unobstructed view of the 2,000-pound carnivores. Constructed of reinforced steel and concrete, the pens were easier to clean and gave the bears more area to roam and a cave to sleep in for privacy. (Courtesy of the Tennessee State Archives.)

The barless bear pits were constructed as part of the Works Progress Administration's efforts to give work to those on relief. It took 100 men working nine months to create what was hailed "a prized asset for Memphis." The enclosure measuring 360 by 80 feet was five times the size of the previous pens and based on a concept by animal trader Carl Hagenbeck, who thought zoo-goers should have an unobstructed view of the animals. (Courtesy of the Tennessee State Archives.)

The bears learned to stand and wave for peanuts from zoo visitors with good throwing arms. Their enclosure was built to resemble the Rocky Mountains, with large overhanging rocks and dead trees for them to climb and claw on.

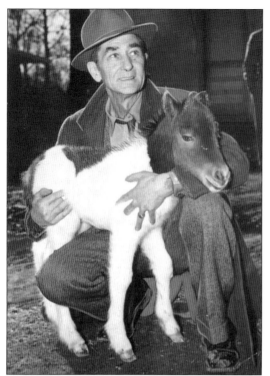

In 1953, N.J. Melroy retired as director at the Memphis Zoo. He was lauded for making the zoo the "Greatest Show on Earth" in Memphis. Each morning before the gates opened to the public, he would stroll the zoo grounds, petting the animals and calling each by name. He spoke to them as if they were his children. According to his late wife, "His worst fault was that he was too nervy with the animals. He'd go right in a cage with a sick animal or one he didn't know, if he thought it needed help."

N.J. Melroy (left) and Hal Lewis, superintendent of the Memphis Park Commission, get acquainted with the zoo's new tapir in 1952. Tapirs are native to South and Central America and Southeast Asia, where they live in dry forests and near rivers and deltas. Like hippos, they can submerge and feed on the river bottoms for extended periods of time.

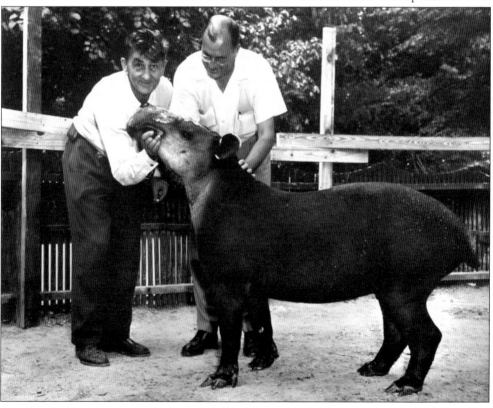

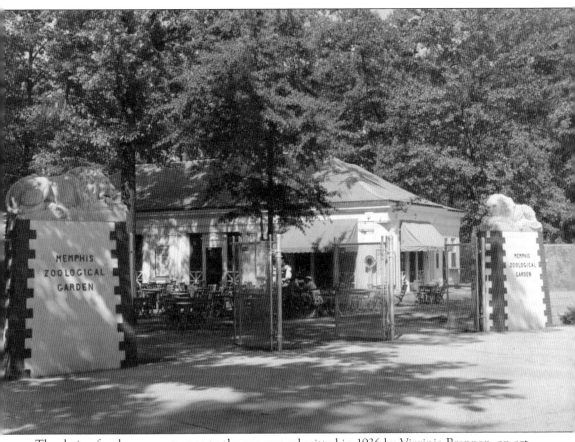

The design for the new entrance to the zoo was submitted in 1936 by Virginia Brennan, an art student at the Art Institute of the South and the daughter of Joe Brennan, chairman of the Memphis Park Commission. The lions flanking the entrance were a gift from the Van Vleet family. Carved in Italy in 1900, the marble carnivores formerly guarded the entrance of the Van Vleet's home located at 1266 Poplar Avenue, until the family's property was sold and became Memphis Tech High School in 1928. At the time, Ramelle Van Vleet was the only life member of the Memphis Zoological Society. The lions are now located just west of the tropical bird house.

N.J. Melroy greets a visitor inside the zoo's greenhouse in 1941. The greenhouse supplied the zoo with many of its flowers and tropical plants and also served as a tropical bird exhibit. Some of the first birds at the zoo included eagles, owls, and parrots, as well as wild chickens, described in 1908 as being "natives of Honduras and in fact . . . the only pair of their kind in captivity." The pair was donated to the zoo by noted explorer H.C. Moore of Corinth, Mississippi. (Courtesy of the Tennessee State Archives.)

Director Melroy and his young assistant Carolyn Smith hold four of the zoo's newest cats—Einie, Meenie, Minee, and Moe—in February 1947. The naming of newborns at the zoo usually fell to the keepers to decide. In the 1970s, the zoo had lions named Firecracker, Dynamite, and Boom-Boom and cheetahs named Punch and Judy.

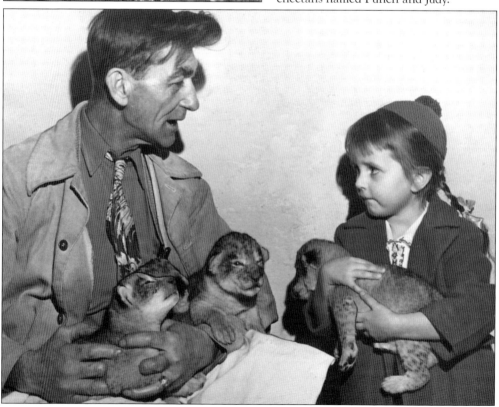

N.J. Melroy, along with his wife, Charlotte, helps a young zoo-goer experience the thrill of petting an African lion in 1951. First, Melroy would pet the lion, talking to it and letting it know everything was okay. Then, he would slowly take the guest's hand and place it on the lion, always staying close by and talking to the animal.

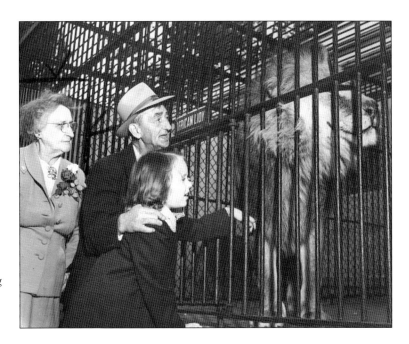

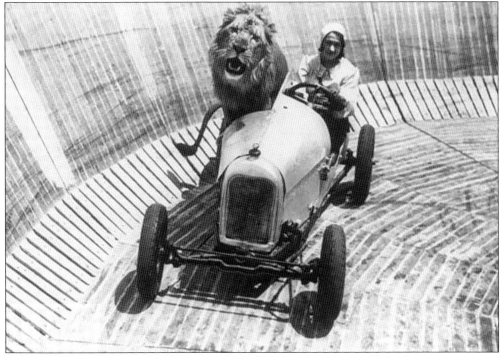

Daredevil lions Prince and Sultan retired to the Memphis Zoo in 1938 after seven years of performing with stunt driver Marjorie Kemp. The lions would ride in the sidecar as Kemp would drive at high speeds inside a cyclodome, a large oval track with high banked walls. Kemp knew N.J. Melroy from his days with the circus and wanted to provide the lions with a good home in their retirement.

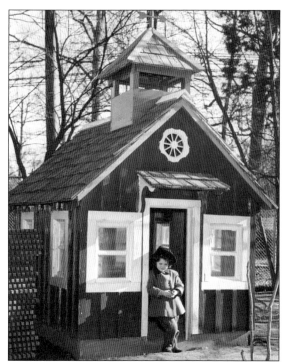

Barbara Mahowen strikes a pose in the doorway of the one-room schoolhouse at Kiddie Land in 1947. The space, located on the southwest portion of the zoo grounds, also included a barn and petting zoo. The kiddie zoo was very popular for many years and operated until the Once Upon a Farm exhibit opened in 1995.

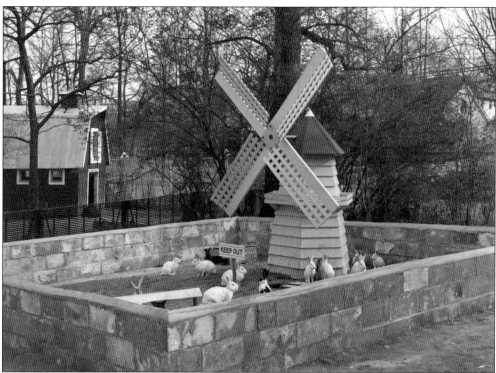

Rabbits scamper around a Dutch windmill in Kiddie Land in 1949. White rabbits were some of the first animals at the zoo, donated by "different ladies and children of the city who take an active interest in the up-building of the zoo," according to a 1908 brochure.

The kiddie zoo at Overton Park was dedicated in March 1947. Here, Jill Striblink (left) and Juanita Temple peek inside the new barn where kids were able to see cows, chickens, and goats. The exhibit allowed children to play and pet the animals and in turn gave the animals much-needed attention.

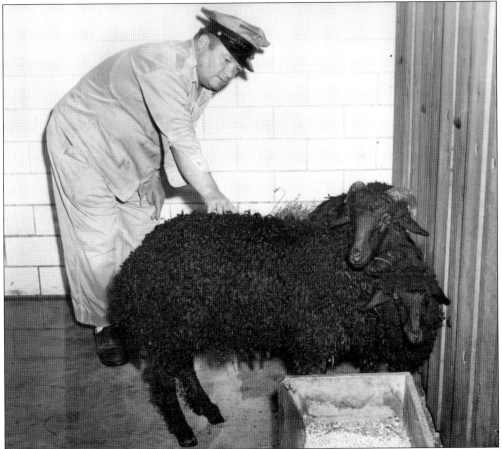

Kiddie zookeeper Enlow "Shorty" Newman inspects a pair of Karakuls in May 1960. Native to Central Asia, the sheep are known for their double coats of dense hair. The outer, coarser fiber is used for carpets and felting material. With their long, shaggy coats, they were a favorite of children in the petting area.

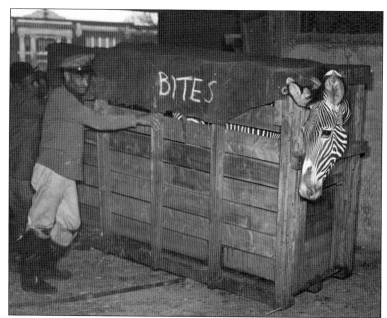

In 1955, the zoo received a new male zebra. Lest anyone should forget, the warning "Bites" was written in large letters on the side and front of the crate. Zebras are very difficult to domesticate and are usually best left alone, as longtime zoo director N.J. Melroy was known to say.

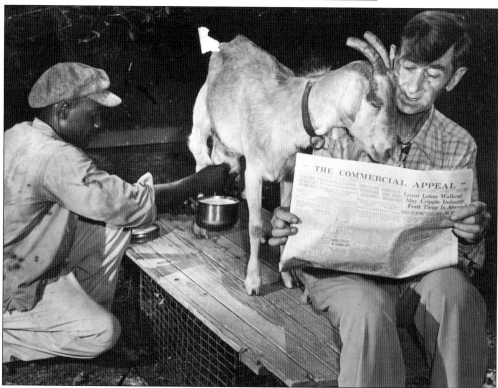

N.J. Melroy distracts a goat with the latest news while a zookeeper collects milk to feed the baby animals in 1946. Melroy had a way with animals. He was known for being on a first-name basis—as he was apt to say—with every animal. By seeing the animals every day, he could better judge their dispositions and sense if something was wrong or if they were sick. He respected them, and in return, they gave him their trust.

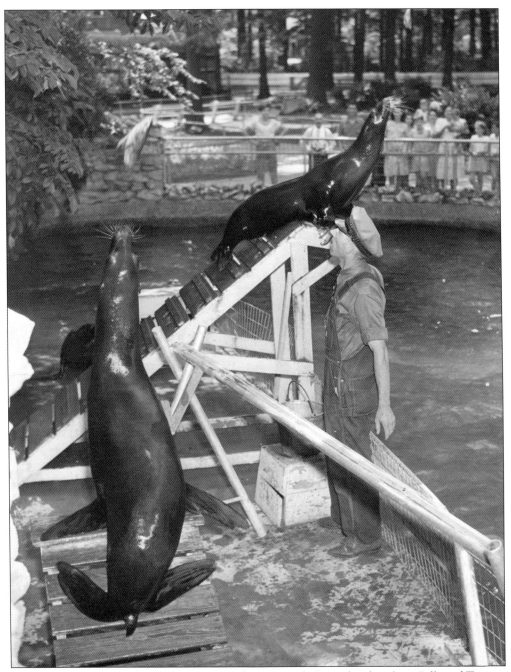

The sea lion show started in the late 1930s, with trainer Bob Conrad and sea lions Billy and Tootsie. Pictured here in the 1940s, the show was popular for many years. In 2009, the sea lions were moved from their home of 70 years and today reside in the spacious Teton Trek exhibit area.

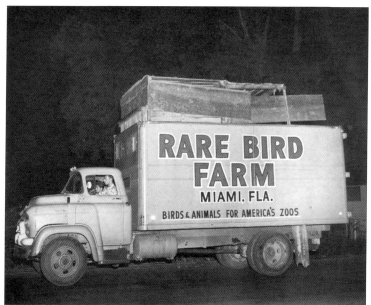

The Memphis Zoo received many of its animals from the Miami Rare Bird Farm. As shown here in 1957, the farm delivered not only birds, but also giraffes, monkeys, and a wide variety of other animals to zoos around the country. The farm's most famous occupant was Enos the chimp, who made the first American orbital space flight in November 1961, paving the way for John Glenn in February 1962.

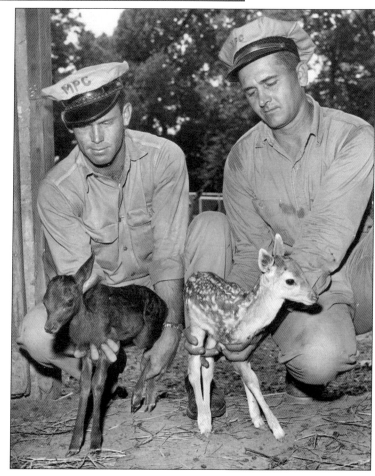

James Cagle (left) and John Tapp care for two young deer in June 1954. Animals at the zoo get attention and comfort they might not get in the wild, where young animals are most vulnerable to predators.

The *Memphis Commercial Appeal* newspaper often helped the zoo with names for new animals by asking the public to make suggestions. A contest was held by the paper to name two new chimps in November 1951. The winning names, Peter and Pan, were submitted by Mrs. E.H. Thomas, in honor of the James Barrie children's book. It is also a play on the species name for the common chimpanzee, *Pan troglodyte*.

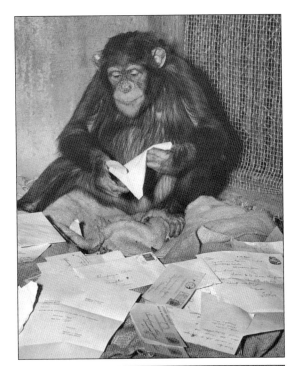

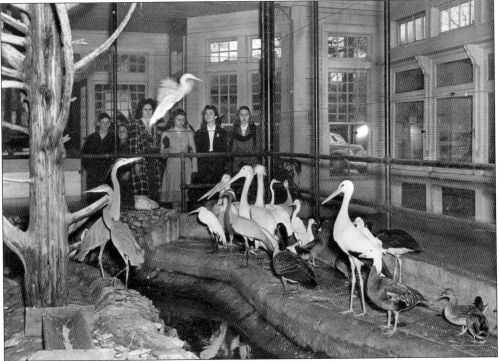

Birds of a feather do flock together. Located in what was originally the zoo's greenhouse, various waterfowl mingle in the indoor aviary in 1941. Some of the earliest birds at the zoo were storks, pelicans, and owls. In 1908, Bill the pelican knew his feeding time and would alert the staff if it was late. He was hand-fed three pounds of fish daily, precisely at 10:30 a.m.

Monkey Island had everything a young monkey could wish for: a slide, diving board, trees with rope swings, and a boat in case the monkeys wanted to make a getaway. It was not uncommon for businesses near the zoo to call to report escaped monkeys in their trees.

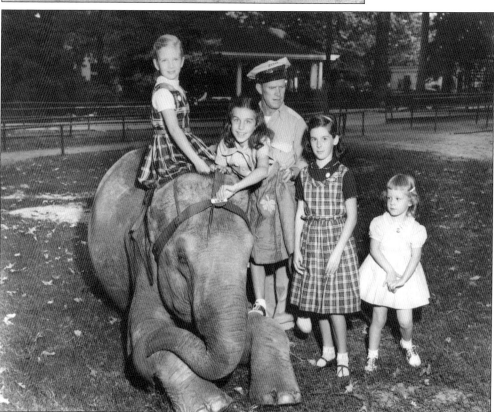

Members of the Iketeers club from St. Mary's School visited the zoo to enlist the living symbol of the Republican Party. Pictured here are, from left to right, Jeanne Stevenson, Janice Donelson, zoo trainer Tommy O'Brien, Joyce Wilkerson, and Cherry Leatherwood preparing for a birthday party in President Eisenhower's honor in October 1956.

Three

MODOC GOES TO HOLLYWOOD

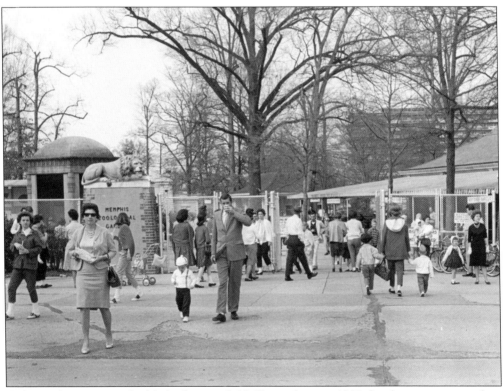

A day at the zoo was a highlight for any child. Shown here in 1963, families come to see their favorite animals. They often got to know them as if they were an old friends. Usually, all a father had to say was "Do you want to go see Adonis?" and junior knew just where to go, if he was not too busy chasing the peacocks.

Tommy O'Brien entertains the crowd during the free circus at the zoo in 1951. Training the animals for the show not only provided entertainment for the crowd, but it also helped when it came time for medical checkups and moving the animals to new quarters.

Goats Whitey and Brownie run through their act with Tommy O'Brien in preparation for the 1962 season of the zoo's free one-ring circus. O'Brien began working the zoo's circus in 1952 before retiring in 1967. Prior to that, he worked 20 years training animals for circuses.

"The world's only free one-ring zoo circus" was how the show was billed. Launched in 1927, the circus would take animals from the zoo and train them for the daily event. Each year, Tommy O'Brien and his family would add new acts, incorporating goats, dogs, horses, and camels into their performance.

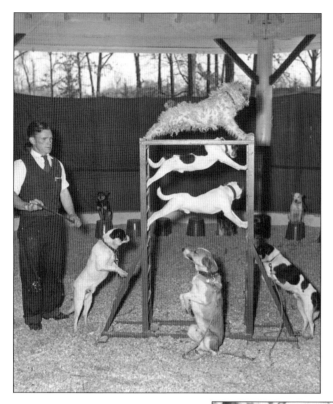

Many of the dogs used in the circus were not actually of the purebred kennel club variety. O'Brien's dogs, shown here in 1949, were often strays found at the zoo or ones who simply wanted to break into show business and hear the applause of 300 screaming children while completing daring acts of agility.

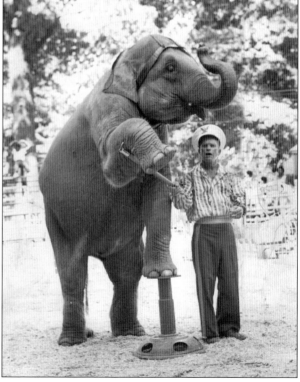

Tommy O'Brien trains Nosie the elephant for the 1956 season of the zoo's free one-ring circus. A favorite since he came to the zoo as a baby, Nosie left the zoo in 1965 to join Modoc the elephant at a private zoo and movie compound near Hollywood. After leaving the Memphis Zoo in 1961, Modoc appeared in several movies and even in a commercial for peanut butter.

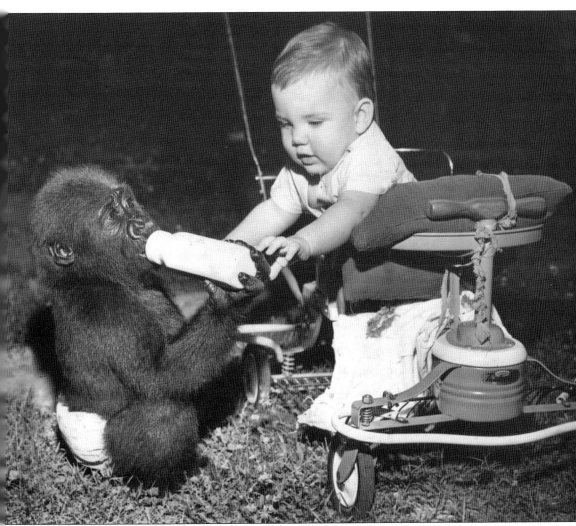

Tammy, born in the spring of 1960, picked up a dropped baby bottle from Raymond Gray Jr., the eight-month-old son of zoo director Raymond Gray. The young gorilla, like many baby animals at the zoo, stayed with the Gray family on zoo property until she could live on her own. From the opening of the zoo until the mid-1960s, all zoo directors lived in a house located on the southwest side of the property.

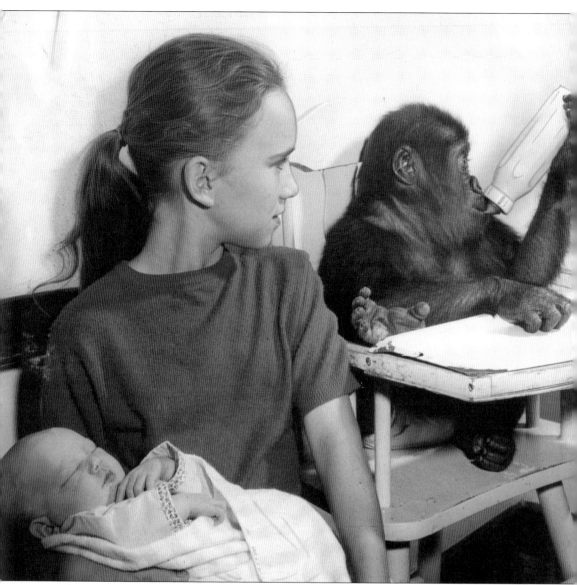

The O'Brien household was far from dull. As curator of the zoo for many years, Tommy O'Brien would frequently bring baby animals home that had been rejected or were in need of care, including Tammy, a young gorilla. As Anita O'Brien babysits younger sister Myra Lynn in 1961, she keeps an eye on Tammy, too.

A giraffe makes his way via train to the zoo in 1945. In the early days of the zoo, animals would come directly from their country of origin. A hippopotamus might be caught in Africa, sent overland to London, and shipped to the United States within a month. Nowadays, animals are mostly traded between zoos within the same country. The use of the Species Survival Plan, developed in 1981 by the Association of Zoos and Aquariums, helps focus on those animals in danger of extinction in the wild. The program helps to maintain healthy and genetically diverse animal populations within the zoo community.

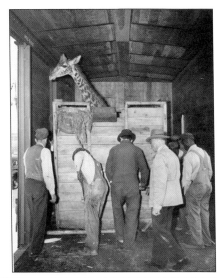

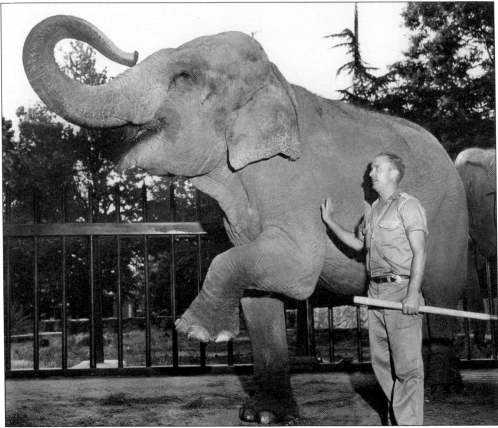

Abandoned by the circus and left at the Mid-South Fairgrounds in 1953, Modoc the one-eyed elephant arrived unceremoniously in Memphis. Tommy O'Brien, who had worked with Modoc before coming to the Memphis Zoo, walked the large pachyderm from the fairgrounds two miles back the zoo. Modoc was kept at the zoo for 10 years before leaving for Hollywood in 1963. He became a regular on the television show *Daktari* and also appeared in many commercials.

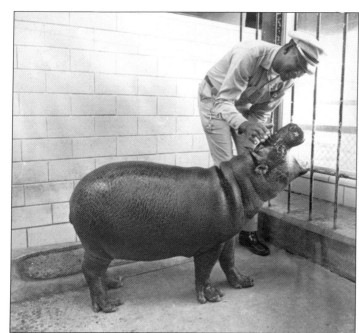

Lestzler Taylor comforts a baby hippopotamus in 1975. Baby hippos are born underwater, having to swim to the surface to get their first breath. A mother typically gives birth to a single calf weighing between 55 and 100 pounds, although twins do occur, as in 1988 when Julie gave birth to Splish and Splash on Christmas Day.

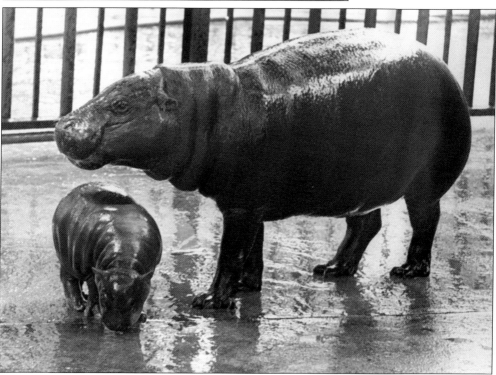

The first pygmy hippopotamus born at the Memphis Zoo arrived on January 14, 1971. Born to Jo-Jo and Zulu, the baby hippo weighed six pounds and added Memphis to Cleveland, Ohio, and Washington DC, as the only zoos to successfully breed pygmy hippos. With a population under 3,000, the pygmy hippo is currently listed as endangered by International Union for Conservation of Nature.

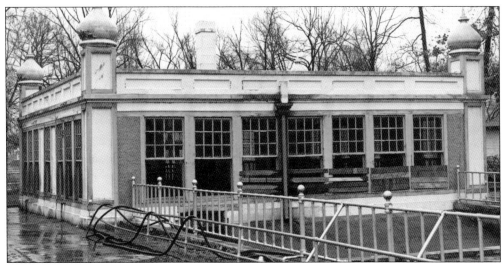

The original hippo house at the zoo was built in 1916 at the same location the hippos occupy today. The rails, tile floors, and outdoor pools still remain from the original structure. In 1916, the hippos marched from Galloway Hall to their new home just as they will in 2016, when they will be introduced to their new home, the Zambezi River Hippo Camp. The new exhibit will occupy the location of the old bear moats, which were demolished in 2014.

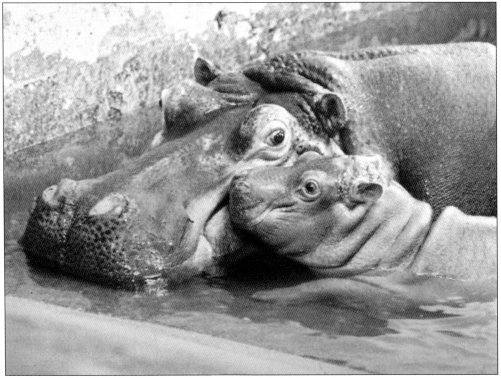

Little Fella was born on December 23, 1969, to Julie, daughter of the zoo's patriarch hippo, Adonis. He already weighed 400 pounds at four months old and was the 29th hippo to be born at the zoo. He was sold to the Oakland Baby Zoo in 1970 for $1,200. In the 1930s, an adult hippo would have sold for $3,500.

Longtime hippo keeper Will Flynn visits Venus and Adonis after his retirement in 1955. The hippos were brought to the Memphis Zoo from Germany in 1914, and Flynn cared for them until his retirement. Adonis passed away in 1965 at the age of 54, making him the oldest hippo in captivity. Venus passed away in 1955 at the age of 43, and their many offspring have populated zoos across the nation.

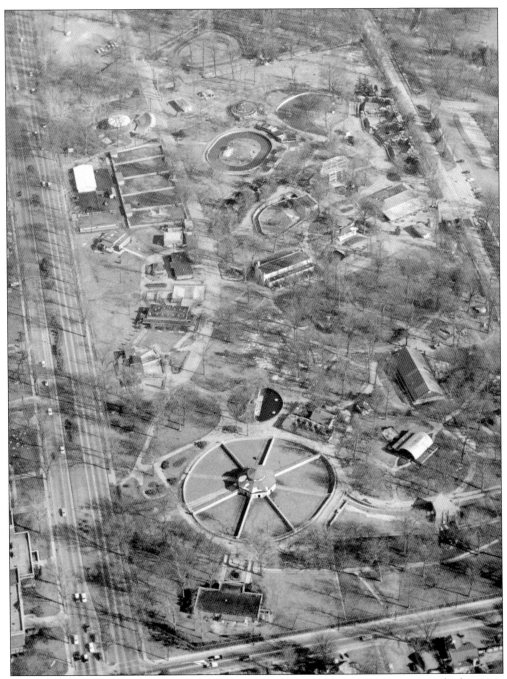

An aerial view of the zoo around 1950 shows the round barn in the lower center, the bear pits in the upper right, and the Carnivora building in the center. The area at top, where the African Veldt is located today, was just being cleared. North Parkway, to the left, was originally known as the Speedway in the early 1900s and was designed by George Kessler, who also planned Overton Park.

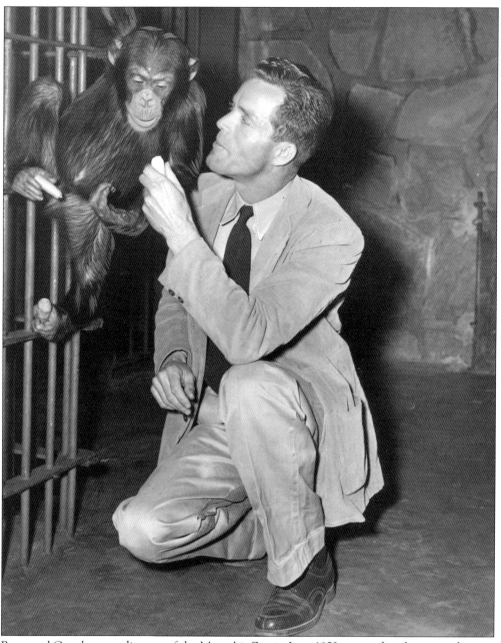

Raymond Gray became director of the Memphis Zoo in June 1953, succeeding longtime director N.J. Melroy. Gray was previously director of the Little Rock Zoo, where his father, W.M. Gray, served as one of the first zookeepers when it opened in 1926.

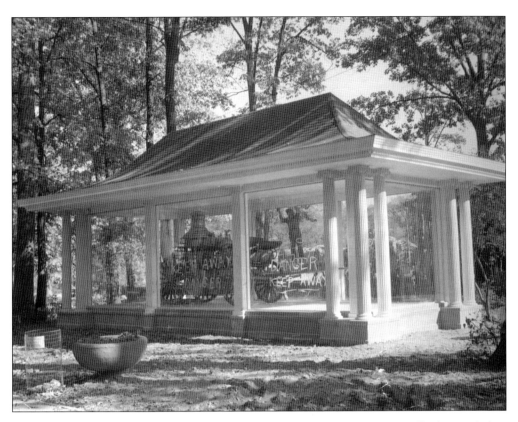

The E.H. Crump horse-drawn fire engine was housed at the zoo in a specially designed glass pavilion, beginning in 1944. The equipment was purchased by Crump when he became mayor of the city in 1910. Shown in action around 1912, the steamer is traveling west on Union Avenue and making a right turn onto Main Street.

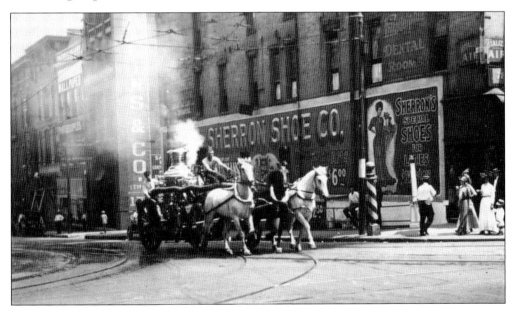

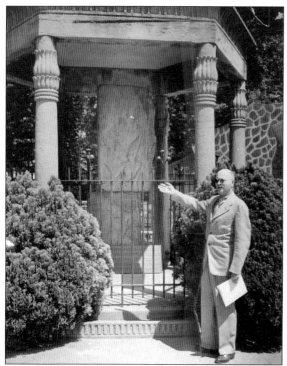

It took a visiting professor who spoke 24 languages to catch a mistake on a text panel describing an ancient Egyptian column just inside the zoo's entrance. The massive stones were from Memphis, Egypt, and graced the doorway of the palace of Amasis, the last native king of ancient Egypt. The panel listed the king's reign in the Twelfth Dynasty but Dr. William F. Allbright said the ruler was from the Twenty-sixth Dynasty some 1,300 years later. The column was moved in 1965 to the lobby of Memphis City Hall.

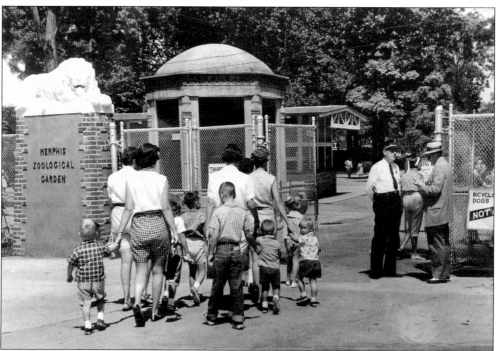

The boys would have to skip watching *The Howdy Doody Show* on TV today. Going to the zoo and passing beyond the stately lions was always an experience for any kid. Shown here in 1960, the round-topped pavilion holds a column from the palace of King Amasis of Egypt. Standing guard at the gate is Dan Peebles, who began his career as a policeman in Overton Park in 1939.

In 1953, an unidentified young student from Ford Road Elementary School poses for the camera—as so many other zoo visitors have throughout the years—while capturing a time when separate but equal was the norm. Soon things would change. It was a year before the Supreme Court desegregated schools in the landmark *Brown v. Board of Education* case. And until 1960, African Americans were only allowed to visit the zoo on one day each week, Thursdays, and in later years, on Tuesdays. (Courtesy of Earnestine Jenkins Collection)

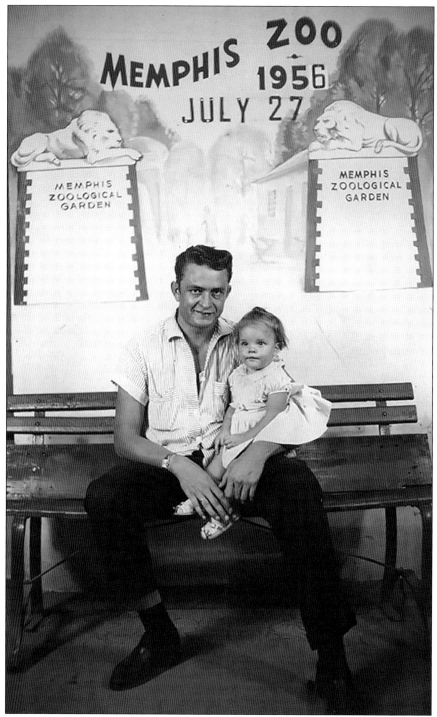

Johnny Cash recorded "I Walk the Line" at Memphis Sun Studios in May 1956. On July 7 of that year, he played to a capacity crowd at the Grand Ole Opry in Nashville. Two weeks later, Cash took a Friday off and spent a day at the zoo with his baby girl, Roseanne. He lived around the corner from the zoo during the mid-1950s and was a frequent visitor.

The rhinoceros house at the zoo was completed in 1958 at a cost of $40,000. The exhibit contained large translucent windows to let in light and featured blue tile inside the building. A female rhino, purchased for $2,500, was the zoo's first since opening in 1906. A tapir was also purchased for the neighboring pen.

Up until the 1960s, the zoo would close for a few weeks during January and February to allow the staff some vacation time and to repair and update the exhibits. In 1952, the staff totaled 15 workers. Today, the zoo has a daily staff of 90, including 120 volunteers.

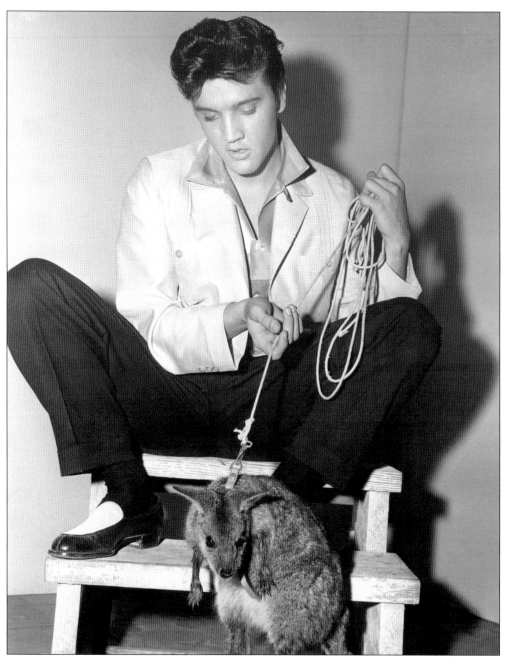

While filming *Jailhouse Rock* in 1957, Elvis received a wallaby from a fan in Australia. The young marsupial stayed on the set and became the unofficial mascot for the movie while in Hollywood. After filming, Elvis sent the wallaby to the Memphis Zoo. A special enclosure was built in Kiddie Land for the animal, and while the wallaby was in quarantine, the main office was flooded with calls from girls wanting to know when they would be able to see the new animal star. (Courtesy of Elvis Presley Enterprises, Inc.)

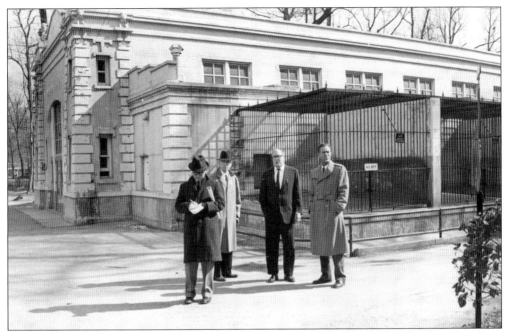

Pictured from left to right, park commission members John Gorman and Richard Dober, along with park commission chairman Hal Lewis and zoo director Raymond Gray, look at ways to improve the zoo in 1963.

Easter at the zoo in the 1960s brings out children with their baskets ready to find the golden egg. Shown here in front of Kiddie Land, the entrance to the zoo is on the far left, with the photo booth in the center.

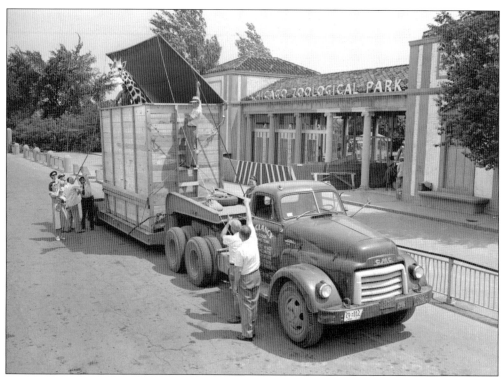

May the giraffe prepares to leave the Chicago Zoological Park in 1959 for her trip to the Memphis Zoo. The specially designed crate allowed her to stretch her legs and her six-foot-long neck during the drive to her new home. (Courtesy of Corbis Archives.)

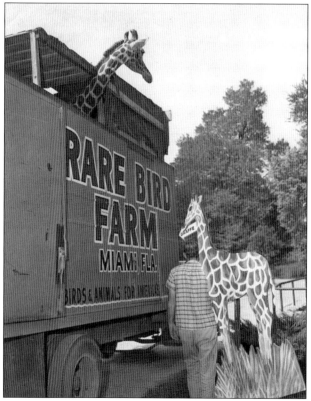

The Rare Bird Animal Farm delivers another giraffe to Memphis. The newest addition to the Memphis Zoo gets a glimpse of its new home before being unloaded. Before the interstate highway system, the trip from Miami to Memphis could take up to a week and pass through many small towns. A crowd would gather at most gas stations to see what exotic cargo the company was hauling.

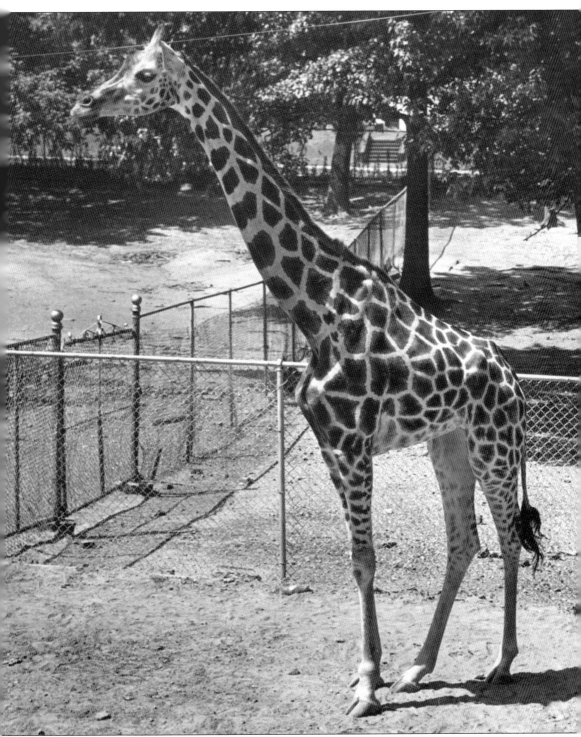

May, pictured here in 1960, found a good home in Memphis. In October 1962, Andy, who arrived in 1957, and May had a baby, Cindy Lou. Baby giraffes are six feet tall and 125 pounds at birth, and the mother gives birth standing up. (Courtesy of the Dye Collection.)

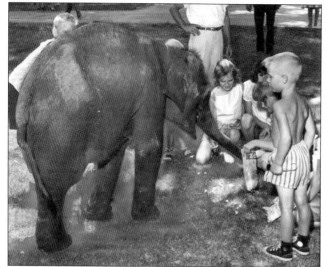

Children gather around to welcome Connie to the zoo in 1965. When a new baby elephant was acquired by the zoo, keepers would take it to an open area for the children to pet. The kids loved it, and the attention helped the animal feel calm in its new surroundings.

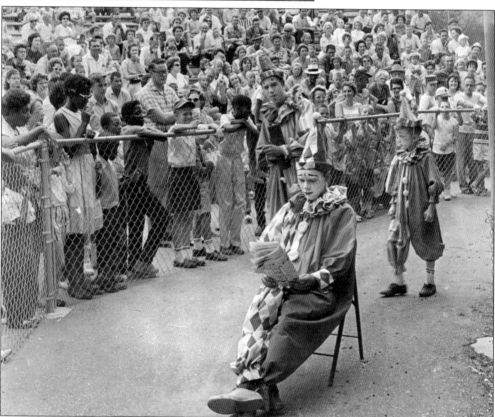

The free one-ring circus was started in 1925 by N.J. Melroy, who kicked off the event with a comical bucking mule named Old Pete. Through the years, a variety of animals, including dogs, goats, camels, and horses, participated in the performances. Zoo employees and even neighborhood children were included in the show. Louie Bell (far right) became a part of the act in 1963. He would later be given a more permanent position with the zoo in 1972, working with the lions—a job he still holds today after 42 years.

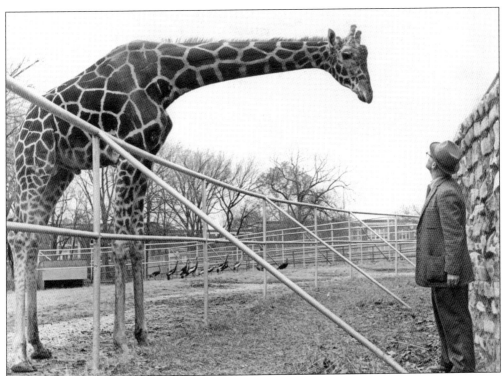

Zoo curator Tommy O'Brien examines Andy the giraffe after a long recovery from whipworm parasites, which are spread by pigeons. Untreated, these parasites can weaken the heart and cause weight loss and eventual death. Andy was nursed back to health by O'Brien and the zoo staff in 1965.

Hal Lewis (left), chairman of the Memphis Park Commission, chats with guests and a friendly peacock at the zoo in 1963. Elvis donated several peafowl to the zoo when he discovered the colorful birds pecking at their reflections in his Rolls-Royce at Graceland.

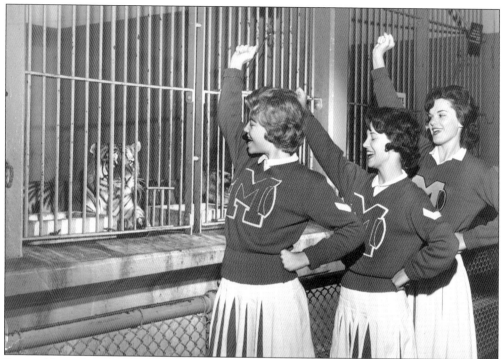

Pictured here, from left to right, are Liz Alsobrook, Lolita Pew, and Rene Plaisance cheering on Sheik, the Memphis State University Bengal tiger mascot, in November 1963. It would not be until 1973 that a zoo tiger would accompany the team to its home games. The first to receive this honor was Tom, the mascot for the Memphis State Tigers, who called the zoo home from 1973 until 1992.

Originally named Galloway Drive in honor of Robert Galloway, the street at the current entrance of the zoo was initially a rail line for the Memphis Street Railway Company, carrying passengers from downtown Memphis, through midtown, Binghampton, and on to Raleigh, Tennessee. In the 1940s, the trolley line was removed and a bus route took its place. The street was renamed Prentiss Place after Carol and Jim Prentiss, whose generous donations over the years helped to make the Memphis Zoo one of the best in the nation.

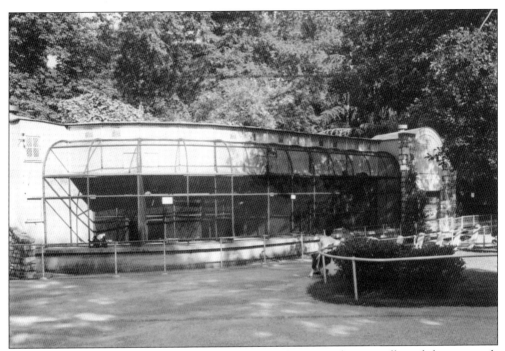

Before the primate house was completed in 1967, monkeys stayed in a smaller exhibit area with seating in front for guests to sit and watch the animals play. Early monkeys exhibited at the zoo in 1908 were Java monkeys, Madagascar monkeys, and spider or ring-tailed monkeys.

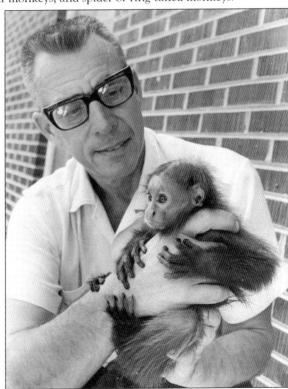

Zoo director Robert Mattlin cares for Doug, a newborn rhesus monkey born on Monkey Island in 1967. Built in 1936, Monkey Island contained 75 Java, India rhesus, and African green monkeys when it opened. Abandoned by his mother, the infant spent the next eight months in Mattlin's office while being cared for by the director. Rhesus monkeys rarely abandon their young, except when it is their firstborn.

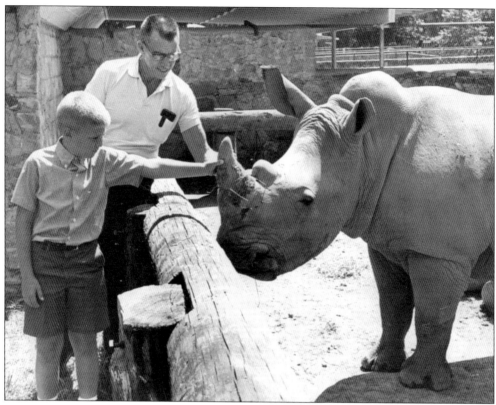

Nine-year-old Wesley Noss always knew he wanted to work at a zoo, so in 1965, the young boy from Paducah, Kentucky, wrote a letter to Memphis Zoo director Robert Mattlin asking if he could visit. Mattlin gave him a personal tour he would always remember. Noss got to pet a white rhino, handle a snake, and even shake hands with Jinx the chimp.

Chicago native George Moeller came to the zoo in 1960 with an encyclopedic knowledge of birds and the need for a job. Raymond Gray hired Moeller, who managed over 200 species of birds in the tropical bird house as well as 20 large birds in the flight cage and 50 ducks, geese, and swans throughout the park.

Four

NEW HABITATS

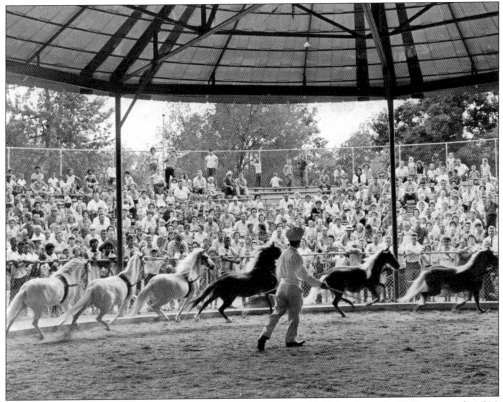

Tommy O'Brien entertains a full house at the zoo's circus in 1963. In the early 1960s, a new $17,500 circus arena was built, located just east of the present-day China exhibit. O'Brien not only ran the circus but was also the curator of animals for the zoo. His knowledge of animals came from years of real-world experience working closely with nearly every type of animal.

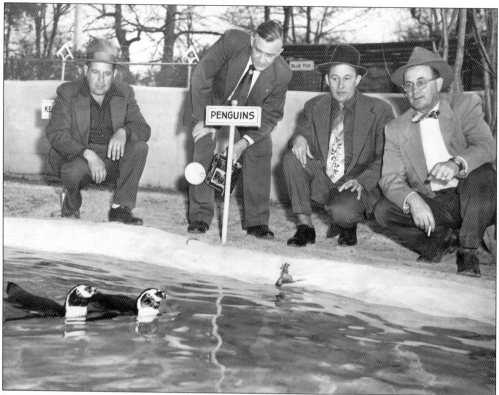

In 1952, members of the Memphis press and zoo employees greet the zoo's newest inhabitants, a pair of penguins. Pictured here are, from left to right, Thomas Yanda, Dr. C.L. Baker, Jack Crump, and Russel R. Aschinger watching the penguins adapt to their new home.

Aoudad Mountain awaits it climbers. In the summer of 1969, the zoo purchased four Aoudad, or Barbary, sheep for the newest installation, shown here near completion. The exhibit today holds the zoo's African penguins.

Opening day at the new aquarium drew large crowds of more than 4,000 on October 4, 1959. One of the first air-conditioned buildings in Memphis, the aquarium displayed not only local fish, but also marine life from around the world. Also included were turtles, newts, salamanders, and crawfish. The aquarium was built with the help of a $100,000 gift from an anonymous donor.

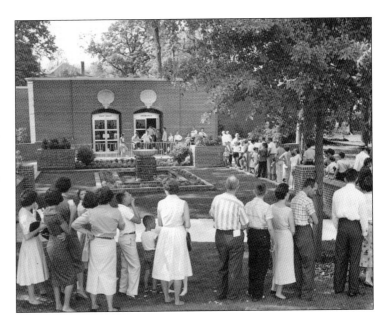

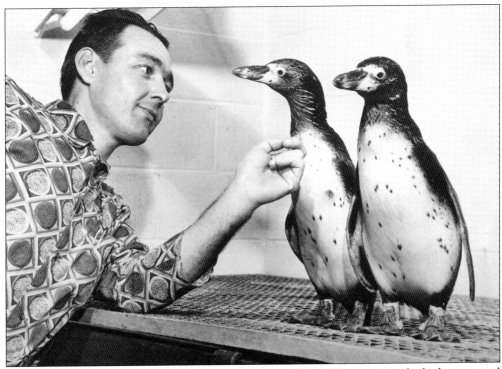

Ronald Graves, curator of the zoo's aquarium, greets two Humboldt penguins who had just arrived from the Miami Rare Bird Farm in 1963. The speckled birds are from the warmer regions of South America and do not have to have refrigerated exhibit space like the more formally dressed Antarctic penguins do.

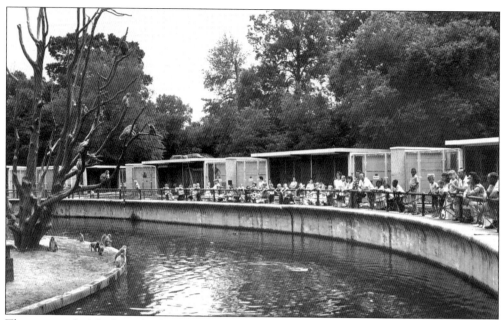

The concept for Monkey Island was not unique to Memphis. Many cities had similar exhibits built by the WPA in the 1930s. Themes included castles, pirate ships, or even lost South American cities. Monkey Island at the Memphis Zoo was demolished in 1993 to make way for Primate Canyon.

In 1955, Galloway Hall, the first exhibit building at the zoo, was torn down and replaced with the snake and reptile house, shown here in its final weeks of construction. In 1971, the Herpetarium was built to house the zoo's many snakes and reptiles and replaced the building seen here.

Kids come running to tell their moms what they saw in the reptile and snake house. In the 1950s, the Memphis Zoo began a long-awaited expansion. With money from private donors and the City of Memphis, almost everything was improved. The reptile house, seen at right, was built for $27,000 and enhanced the quality of life for the animals. Back in 1908, the zoo contained numerous snakes, including a rattlesnake, blue racer, and spreading adder.

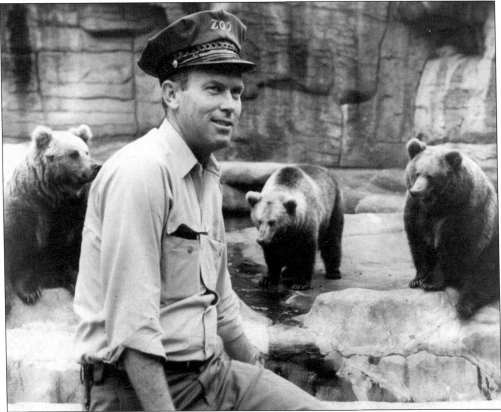

A zoo curator for many years, John Tapp sits in front of the bear moats built in 1938. As the curator of mammals, he had to know about each animal, including the grizzly bears seen here. Understanding their diet, sleep patterns, and temperament came from years of research and observation.

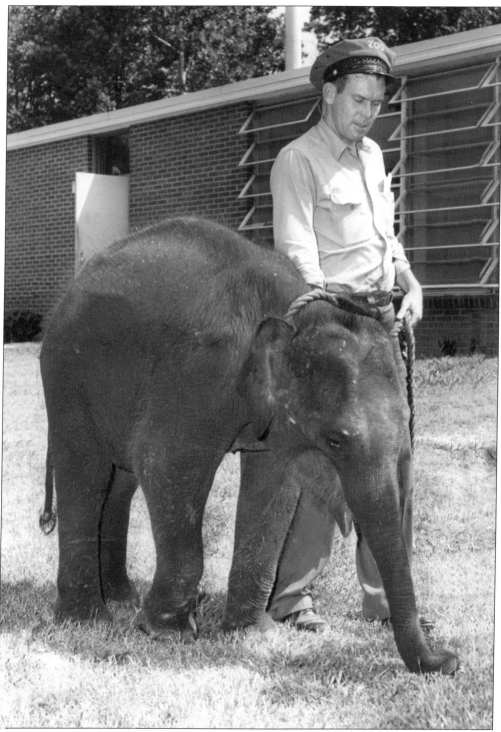

Mammal curator John Tapp shows Tiny, the zoo's newest elephant, around in 1961. Tiny arrived by truck from the Miami Rare Bird Farm and was kept in the 1909 Pachyderm building. Before burning in 1983, the director's residence at the zoo was known as the Tapp House.

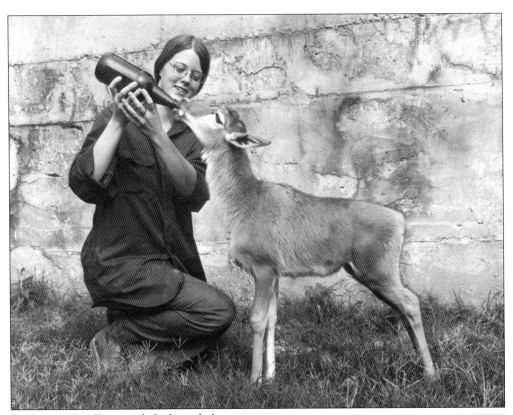

Debbie Blackwell gives a baby bontebok his bottle in 1971. Employees at the zoo work there for their love of animals. They give their time and energy to care for the animals, which are large, unpredictable, and often dangerous. When Blackwell saw a baby giraffe trapped in a fence, she immediately tried to help rescue it, jumping into the enclosure to help. Not realizing her intentions, the mother giraffe injured Blackwell, kicking her and knocking her unconscious. She never recovered from her injuries. After being in a coma for 20 years, Debbie Blackwell passed away in 1996 at her parent's home in New Orleans, Louisiana.

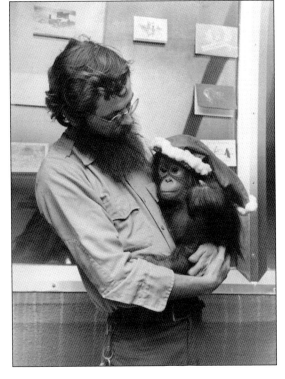

Richard Meek, the zoo's curator of education, holds Woody, a 10-month-old orangutan, during his first Christmas in 1977.

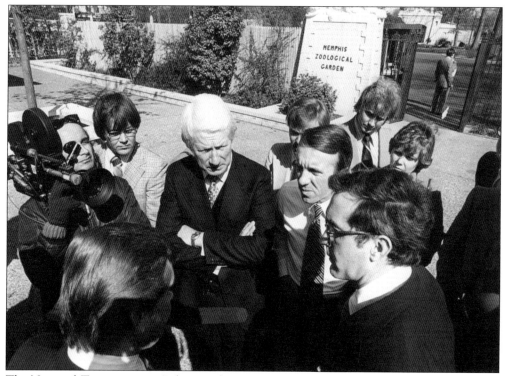

The National Transportation Policy Study Committee meets in front the zoo, then known as the Memphis Zoological Garden, to discuss the proposed route of Interstate 40 through Overton Park in 1978. Beginning in the 1960s, 26 of the park's 342 acres were slated for the extension of Interstate 40 through the park, to run just south of the present-day entrance of the zoo. A small number of residents formed a group, Citizens to Preserve Overton Park, and challenged the plan in court. The Supreme Court decided in March 1971 in favor of Overton Park, and the interstate was rerouted around Memphis.

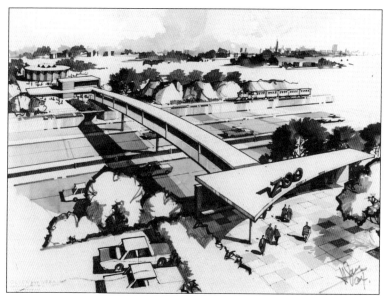

With the prospect of Interstate 40 being extended through Overton Park on the south side of the zoo, architects Olsen and Urbain of Chicago came up with various designs of how the zoo could adapt to the new layout. In this blueprint, parking is on the south side of the interstate with a pedestrian walkway connecting to the zoo.

Connie the elephant overlooks construction of the new primate house exhibit in October 1967. The area was formerly the wolf moat pens, and the elephant moat connected to the Pachyderm building. The primate house was home to apes and monkeys until being converted into the Creatures of the Night exhibit in 1995.

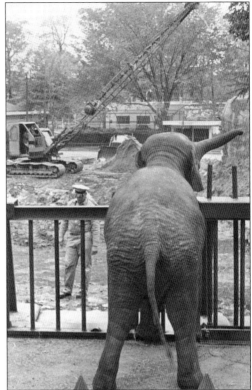

When Charles Wilson took over as director of the Memphis Zoo, he was 28 years old and had previously managed the Little Rock Zoo for just under two years. At a press conference before starting at the zoo in December 1976, he named his four basic philosophies for the institution: conservation, research, education, and recreation.

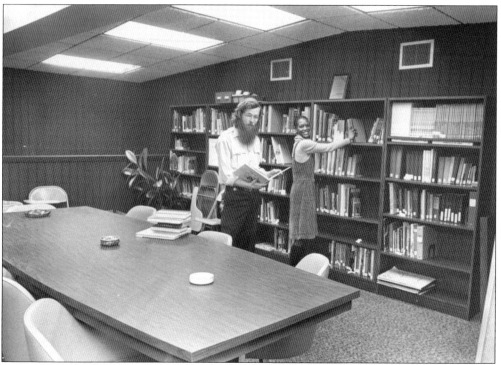

Richard Meek, coordinator of educational services, and staffer Terencelyn Johnson organize books in the zoo's new education building in 1979. Housed in the 1909 Pachyderm building, the library gives employees access to the zoo's long history and up-to-date information on trends in animal care and scientific study.

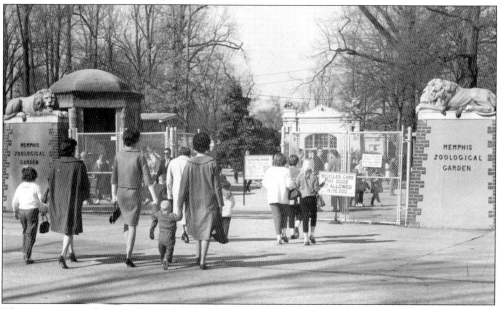

The entrance to the zoo changed little after the Van Fleet lions were installed in 1936. It was not until 1993 that a major renovation occurred with the Egyptian-themed entrance currently used. The 1909 Carnivora building can be seen in the background.

Connie, the zoo's Asian elephant, enjoys a cooling shower during the hot days of summer in 1966.

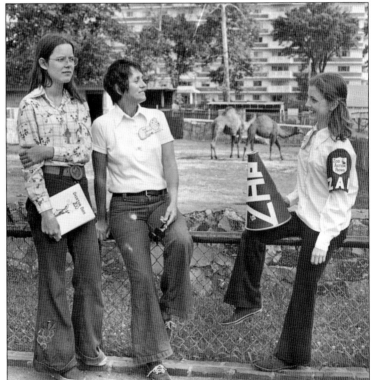

The Zoo Action Patrol, or ZAP, was launched in 1972 to provide information to zoo visitors and help protect animals from mistreatment. New patrol members Lisa Tronsor (left) and Ann Angier (center) discuss their duties with ZAP instructor Donna Fisher in 1973.

Monkey Row, shown here in 1963, was built at a cost of $70,000 as part of a 10-year renovation of the zoo. Almost every building was given a face-lift in some way, with the exception of the Carnivora building and the elephant house. Improvements included a $55,000 rhino house, a $10,000 administration building, a $22,000 hospital, and a $17,500 circus arena.

The $500,000 primate house, completed in 1969, included enclosures for 22 different primates and a kitchen where food was prepared and shown to the public through glass windows. In 1995, the building was converted into the Creatures of the Night exhibit.

Jean Richardson prepares food at the zoo's Primate House, built in 1968. Food was prepared in open sight of the guests through large viewing windows. A typical grocery list for the zoo includes over 5 tons of carrots, 7.5 tons of bananas, 13,000 bales of hay, and 75 pounds of earthworms each year. Dieticians work closely with curators, keepers, and veterinarians to make sure the animals are eating healthy.

Zookeepers move a mandrill (related to baboons) into its new quarters during moving day for the primates in 1969. Mandrills are the largest and most colorful of the Old World monkeys, with males weighing up to 100 pounds. Found in Nigeria, southern Cameroon, and the Congo, mandrills prefer tropical rainforests and habitats adjacent to savannas.

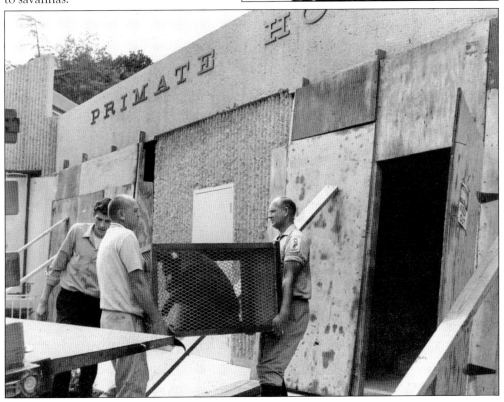

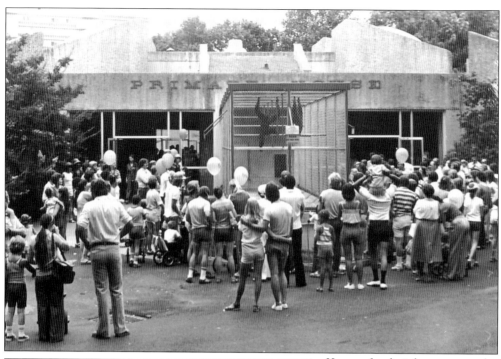

Known for their long arms and ability to swing from rope to rope, the howling siamangs from Sumatra put on an aerial show at the primate house in 1979. Their howls were heard throughout the zoo and sometimes in the adjoining neighborhood.

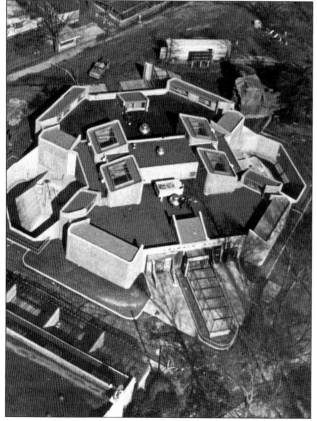

In July 1967, the zoo proposed a new $400,000 primate house for its apes and monkeys. The building was part of a $4 million expansion that included the African Veldt, sea lion pool, and larger exhibits for hoofed animals such as the bushbucks, camels, and giraffe.

Ray Allen exhibits a baby alligator during the fourth annual Zoo Day, sponsored by the Pink Palace Museum. Started in 1969, the one-day festival featured artists, strolling musicians, lectures, and animal exhibits.

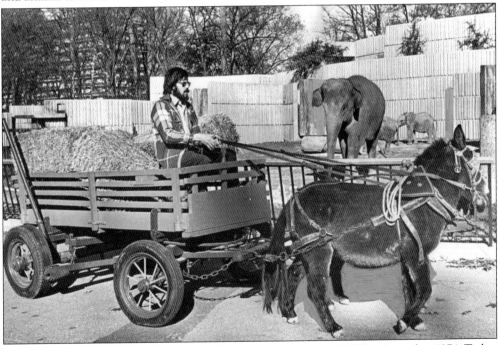

Houston Winbigler delivers hay with the help of ponies Mutt and Jeff in November 1974. Today, Winbigler is assistant curator at the zoo, after working there over 40 years. He is one of the longest-serving employees at the zoo.

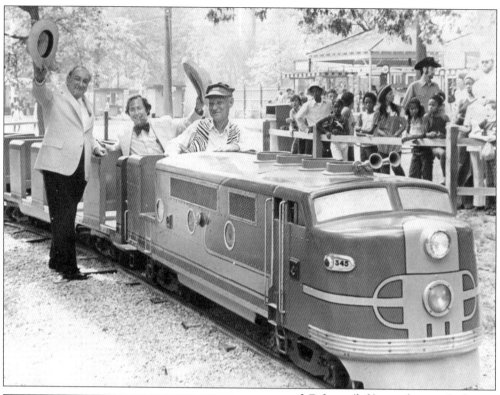

J.C. Levy (left), zoo director Joel Wallach (center), and J.F. Stewart prepare the Safari Express for its first official run in 1975. Levy, who runs the Kiddie Land rides at the zoo, purchased the train from the Mid-South Fairgrounds and hired Stewart, who operated Memphis trolleys and buses beginning in 1923, to act as conductor. The 20-passenger train carried riders on a half-mile tour around the zoo.

Tom, the University of Memphis's mascot, arrived in Memphis as a cub back in 1972. Tom, which stands for Tigers of Memphis, moved to the zoo after being purchased by the Highland Hundred, the university's football booster club. His keeper, Louie Bell, began working at the zoo in 1971 and still oversees the large cats for the *Commercial Appeal*'s Cat Country exhibit.

Julie the hippo gives a photographer a wide smile back in 1991. Julie was the daughter of Adonis, the zoo's patriarch hippo acquired in 1914 from Hamburg, Germany.

The sight of a full-grown jaguar is just too much for six-month-old Melissa Cannon, pictured with her father, Jerry Cannon, in April 1963. Jaguars are the largest cat in the Western Hemisphere and can grow to weigh over 300 pounds. Listed as near threatened due to deforestation and poaching, their populations are rapidly declining throughout their habitat.

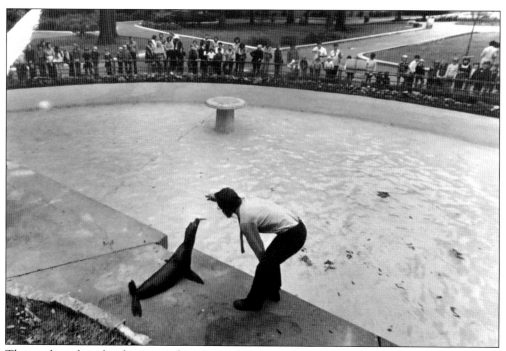

The sea lion show has been popular since it began in the late 1930s. Today, the show is part of the Teton Trek exhibit. Easily trained, sea lions can reach speeds of up to 30 miles per hour and swim to depths of 600 feet, staying submerged for up to 40 minutes.

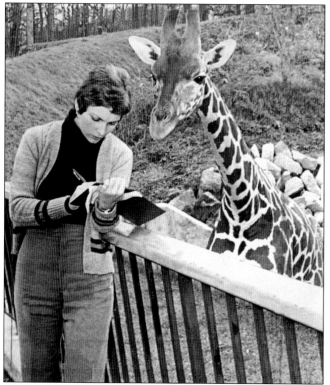

Candy the giraffe oversees Kathy Moore, the zoo's curator of education, as she takes notes for a presentation to the zoo's staff in 1973. The giraffe's species name is *Giraffa camelopardalis*, which alludes to its camel-like appearance and patches of color on its fur.

Shelly Richmond admires her pet frog Batty, which jumped 13 feet and 5 inches to win a national frog-jumping contest held at the zoo in 1977.

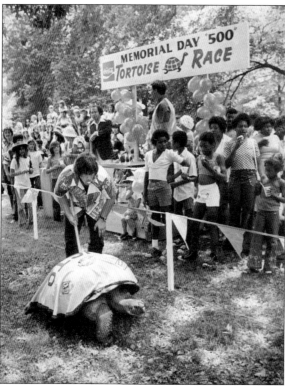

In 1977, the Memphis Zoo hosted the second annual US Open Frog Jumping Contest. Jennifer Sublette (left) and Hank Pierotti encourage their contenders before the competition. The contest was a fundraiser for the American Cancer Society and open to frogs and owners regardless of their age, sex, race, or nationality. "We are an equal opportunity frog jumping contest," zoo director Charles Wilson was quoted as saying.

The second annual Memorial Day 500 tortoise race was held at the zoo in May 1975. The zoo's collection of giant tortoises served as competitors for the sprint to the finish line. The winner was 300-pound Gusto, shown with trainer Louie Bell, completing the 500 inches in two minutes and 40 seconds.

Ronnie Graves gives the newest resident of the zoo plenty of room in 1969. Weighing over 100 pounds, alligator snapping turtles can live up to 75 years and are known for their strong jaws. They were listed as a threatened species in 2006 due to habitat destruction and overharvesting for their meat.

Baby ostriches surround zookeeper Tuli Diamond in July 1977. Ostriches have the largest egg of any living bird, averaging six inches long and weighing three pounds. They lay their eggs in a communal nest, with the males incubating the eggs at night and the females in the day. The ostrich is one of the longest-lived bird species; in captivity, individuals have lived up to 60 years of age.

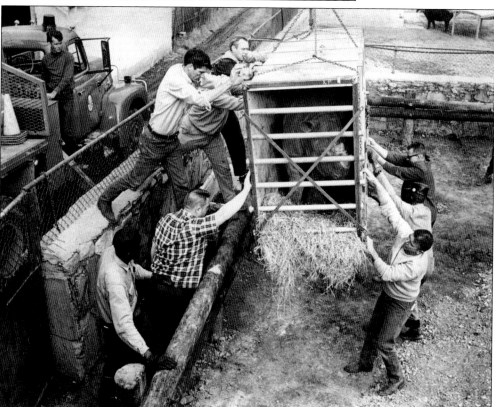

Just moving a rhino to its new enclosure at the zoo can take a small army of dedicated workers. Transporting rhinos Mahlebeni, Baxca, Snoopy, and Olive to their quarters at the newly constructed pachyderm house involved a crane, two trucks, a telephone crew with its own crane to move the wires, and a dozen zoo personal. The new home cost $336,654 in 1972 and is still in use today.

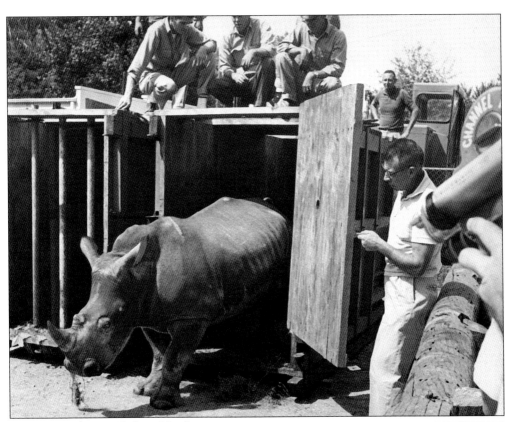

In 1972, zoo director Robert Mattlin (right) opens the door for one of the zoo's three rhinos in its new exhibit area near the African Veldt.

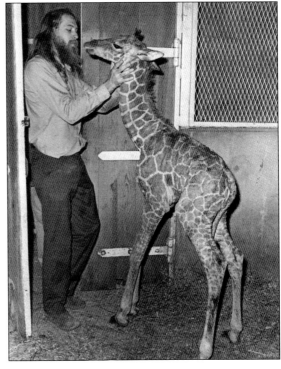

Zookeeper John McDowell helps steady a wobbly newborn giraffe, born to Candy and Gump in December 1975. The new giraffe was named Jingles in honor of the Christmas season. Jingles was the first giraffe born in seven years at the zoo and was given to the Atlanta Zoo as part of a breeding arrangement made when Gump was obtained three years before.

Giving a smart ostrich its medicine is never easy. Lestzler Taylor offers an ostrich a pill wrapped in a leaf to help cure him of an intestinal problem in 1970. The ostrich swallows the leaf but not the pill. When all else failed, zookeepers had to wrestle the six-foot, 250-pound bird—three times a week—into a corner and force the pill into his mouth, hoping he would not spit it back up.

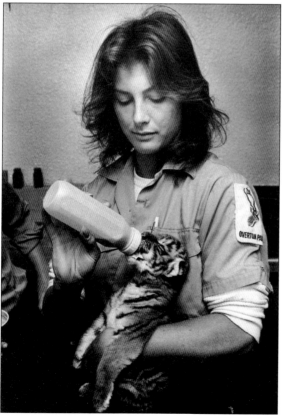

Kathy White bottle-feeds a one-week-old Siberian tiger born at the zoo in April 1978. Named Victoria, the tiger was raised by zoo attendants after her mother rejected her first litter. Siberian tigers are on the endangered species list, with fewer than 450 living in the wild. They are the largest of the tiger species and can grow to 13 feet in length and weigh up to 700 pounds.

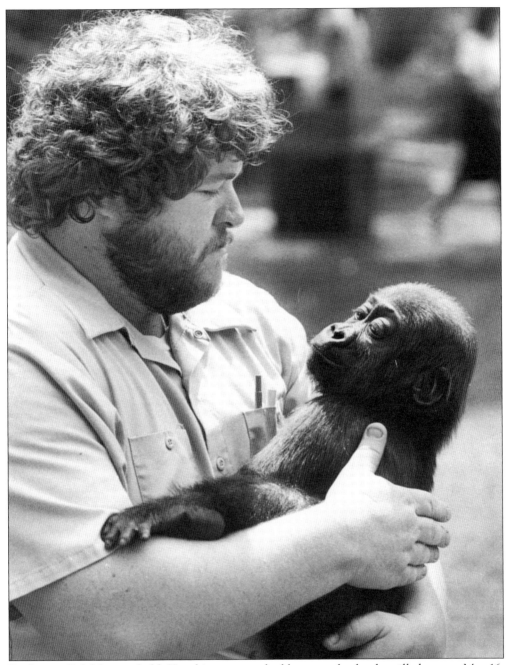

Zookeeper Bob Maguire holds Kwashi, a two-week-old western lowland gorilla born on May 16, 1982. Weighing three to four pounds at birth, male gorillas can reach six feet in height and weigh up to 400 pounds when fully grown.

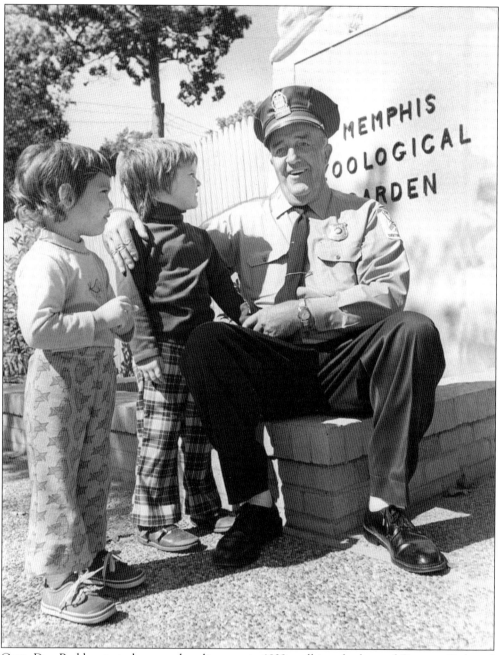

Capt. Dan Peebles started as a park policeman in 1939, walking the beat of Overton Park and the zoo for more than 25 years before retiring in 1964. He was made chief in 1941, with one other officer to patrol the park. Over the years, he witnessed many changes to the park and the zoo.

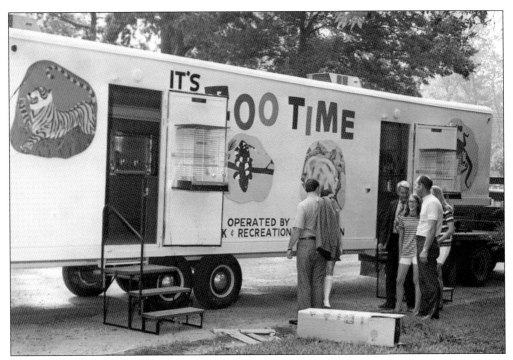

The Mobile Zoo was started in 1971 to spread the message of the zoo to schools, organizations, and communities that might not know all that the zoo had to offer. The zoo on wheels, as it was called, could set up at festivals or events and have a trained staff member discuss the importance of protecting wildlife and allow an up-close experience with an animal.

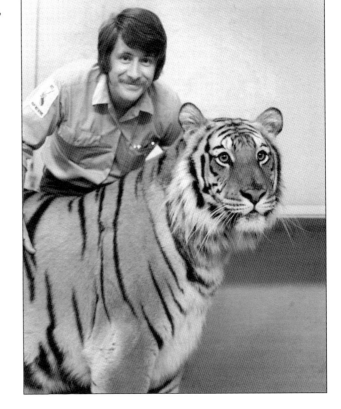

Louie Bell poses with Tom the Tiger, the University of Memphis's football mascot. Bell began working at the zoo in 1971, and is its longest-serving employee, working for five different directors over his 44-year career.

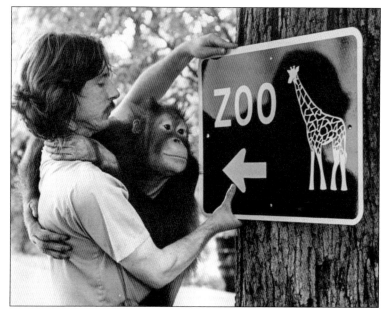

Don Anderson, primate keeper at the zoo, hangs a new sign with the help of baby orangutan Mawas in 1975. Among primates, social interaction is very important—and not only for the animals, as it helps the zookeepers to better understand how a particular animal is feeling.

It is moving day at the zoo. Twin orangutans acquired from the San Diego Zoo, Locke and Lisa, were moved out of quarantine and into the exhibit area with other orangutans in March 1979. Cynthia Stoddard and assistant mammal curator Dan McDonald carry the young primates to the delight of waiting children. The pair appeared several times on *The Tonight Show Starring Johnny Carson.*

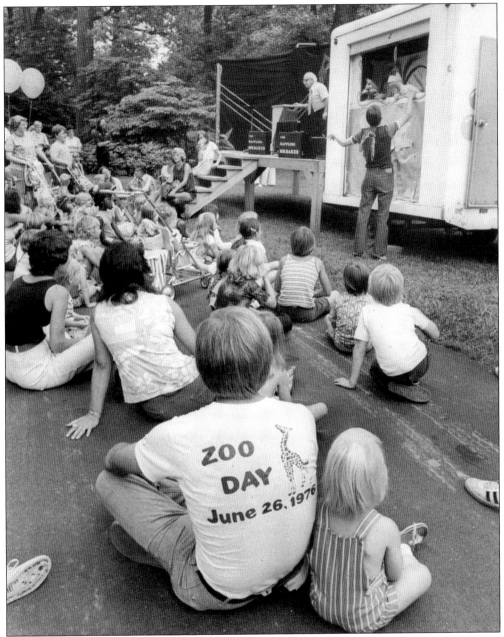

Baffling Mr. Baker sets up his magic show, while Jimmy Crosthwait finishes up his puppet show during Zoo Day in June 1976. Baker, born in 1897, began practicing magic at age 12 and continued until he passed away at age 96. Zoo Day was an annual event highlighted by music, arts and crafts exhibits, and animal demonstrations.

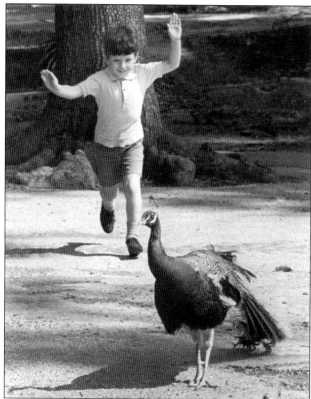

Greg Herbert chases down one of the zoo's 50 free-roaming peafowl in 1968. Zoo superintendent Robert Mattlin said that "the peafowl have been at the zoo for over 50 years and guests come to see the peacock's colorful plumage during mating season with the peahens." He added, "The bird's only predator at the zoo are small boys. Fortunately, few if any actually catch one."

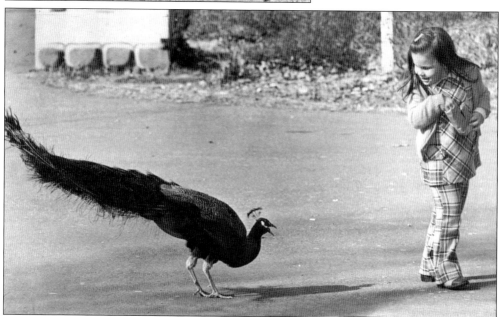

Young ladies take a more indirect approach in greeting the zoo's colorful peacocks. Maybe she thinks it might be one of Elvis's Graceland peacocks, donated to the zoo in the 1960s. Not only did Elvis donate several peacocks to the zoo, but he also donated two wallabies, which were gifts from fans.

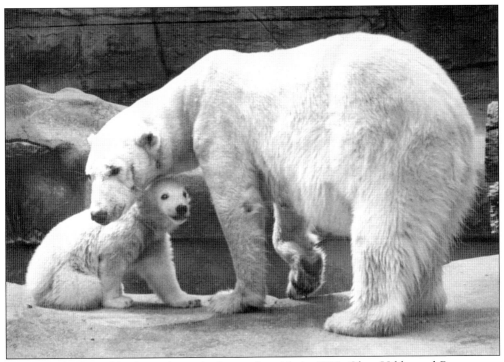

Mother polar bear Olga keeps her cub close to her side in 1976. Olga, Hilda, and Bruno were purchased in 1966 from a dealer in the Netherlands for $3,100.

Zoo director Robert Mattlin cares for Frosty, a one-week-old polar bear cub born at the zoo in December 1970. Most polar bears are born in litters of two, between November and January. Though the newborn cubs weigh 16 to 24 ounces, mothers often gain over 400 pounds during pregnancy.

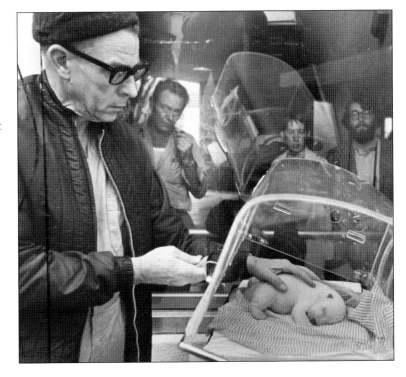

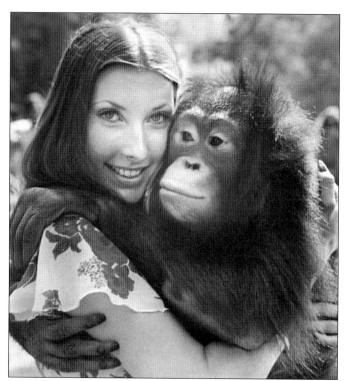

Karen Constin, with the London House Modeling agency, found a new friend in Mawas the orangutan at the zoo's Beauty and the Beast day in 1975.

Charles Wilson took over as director of the Memphis Zoo in 1977, after running the Little Rock Zoo for two years. Driving around in his "mechanical zebra," as he called it, he visited with zoo-goers, answering questions and getting a feel of what he could do to improve the institution. Wilson told a local reporter, "We're one of the best, in the top ten, but I want to say, 'We are the best.'"

It is moving day for the flamingos in 1981. Being guided by their keepers, they adapt nicely to their new surroundings. Flamingos get their pink color from aqueous bacteria and beta-carotene in their food supply.

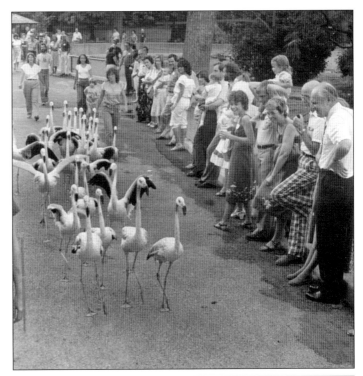

Porky the paper eater was installed at the zoo in the summer of 1969 to help clean up the litter, which had become a constant problem. As paper is put close to Porky's mouth, a vacuum sucks the trash into a container. According to zoo director Robert Mattlin, children were overwhelmed by it, running all over the zoo looking for trash to put in its mouth.

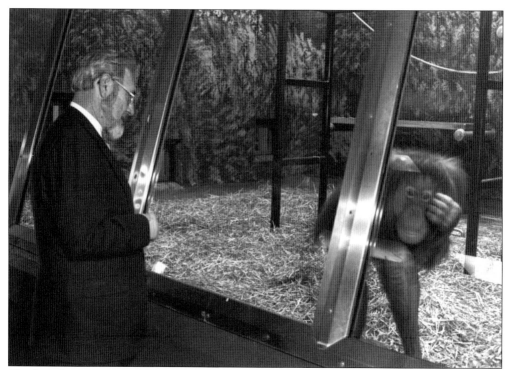

Chickie the orangutan is one of the star attractions at the zoo today. Currently residing in Primate Canyon, Chickie was born in 1977 at the Philadelphia Zoo. After her mother rejected her, zookeepers stepped in to help raise her. When it was discovered that she had a stomach obstruction, Dr. C. Everett Koop, later the surgeon general under President Reagan, operated on her when she was just a day old. She was named after Koop, whose nickname was Chickie. Here, Dr. Koop looks in on Chickie at the zoo's primate house.

Zookeepers Knox Martin and Deborah Scanlan spread gravel around the floor of the renovated open-air tropical bird exhibit in 1988. The new exhibit allows guests to be a part of the birds' world by stepping into their habitat.

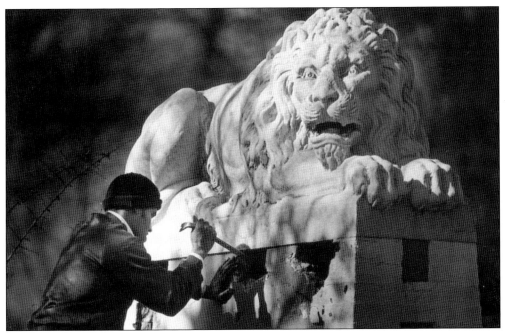

Samuel Wright chips away at the base holding one of the marble lions at the zoo's main gate in 1990. The lions, each weighing 3,000 pounds, were moved to the entrance of the children's area, where they reside today. Originally installed in 1936, the Tuscan marble lions were a donation from the Van Vleet family.

The lions gracing the Carnivora building get a paint job in 1982. According to director Charles Wilson, it was the first time in eight years that the lions had been painted. Standing next to the lions are putti, figures of a boy child that in Renaissance art represented love or a messenger spirit from the divine.

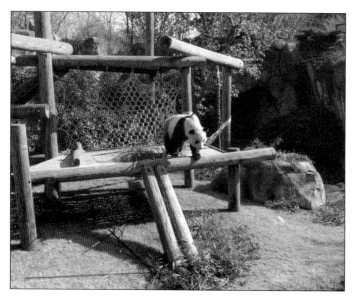

In 1987, Xiu Hua, a giant panda from Mexico, was loaned to the zoo for just 35 days, but over 250,000 visitors came to see her. In 2003, through the efforts of many people, the Memphis Zoo was granted a pair of giant pandas. Ya Ya and Le Le arrived as celebrities, as much as hippos Venus and Adonis did in 1914. Their state-of-the-art facilities allow in-depth study of the rare mammals. Pictured here, Le Le enjoys bamboo, specially grown just for the pandas, in his outdoor exhibit area.

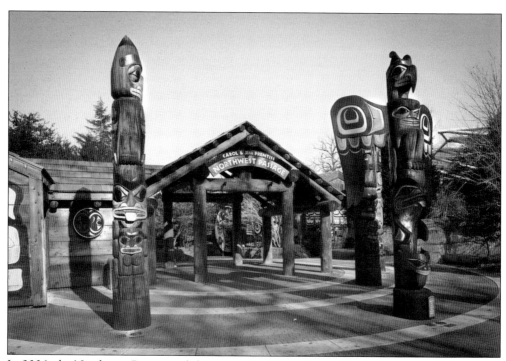

In 2006, the Northwest Passage exhibit opened to house the zoo's polar bears, grizzly bears, sea lions, and bald eagles. The exhibit was named for one of the zoo's largest benefactors, Jim and Carol Prentiss. The $25 million exhibit features an underwater viewing area for the polar bears and sea lions as well as a large aviary for the eagles. The exhibit also gives visitors Native American history from the northwestern part of the United States.

Five

THEN AND NOW

The first renovation to the entrance occurred in 1936, when two Italian marble lion statues were donated and placed on either side of the zoo's front gate.

In the early days, most primates were kept in barred cages for the guests to see. In 1967, a $400,000 primate house was built, giving the animals more freedom. In 1995, Primate Canyon, seen below, was opened, giving the gorillas and other primates a much-improved quality of life. The outdoor areas focus heavily on enrichment activities such as swings and jungle gyms.

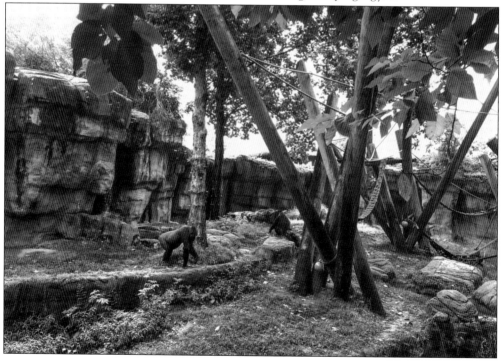

Orangutans, whose name means "person of the forest," are among the most intelligent primates, using a variety of sophisticated tools and constructing elaborate sleeping nests. For many years, they were kept in simple cages with little to keep them occupied. With the addition of Primate Canyon, they now have acres of trees, rocks, and streams to explore and a large sleeping platform, situated high in a tree, to get a bird's-eye view of the guests passing by.

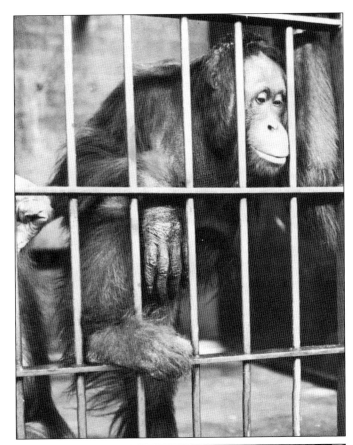

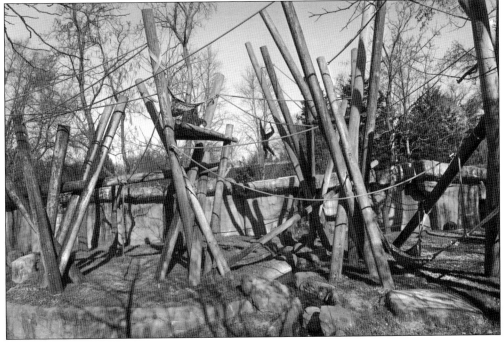

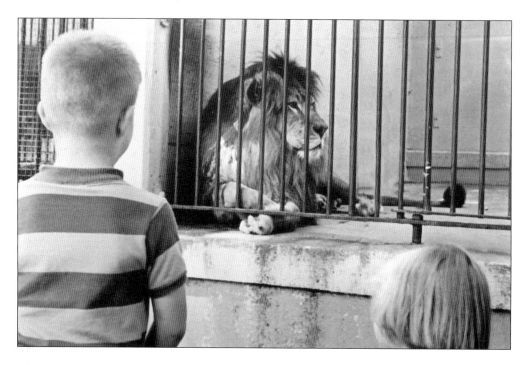

The carnivore house was built in 1909 and consisted of concrete floors and steel bars. For over 80 years, the large cats languished, lying on the hard floor watching guests staring in at them. With the addition of Cat Country in 1993, their lives changed dramatically. For the first time, they could feel grass under their feet, could stretch out on a fallen tree, or walk under a waterfall.

Today, the large cats can explore, dig, or find a secluded spot to rest out of sight of the zoo guests. The exhibit was funded by a leadership gift from the *Commercial Appeal* newspaper. In addition, individual enclosures were sponsored by local citizens and businesses, including Jim Prentiss, Morrie A. Moss, the Kroger Company, and Bryan Foods.

Kiddie Land was started in 1947 to allow kids to get up close to the zoo's more tame animals. With the opening of Once Upon a Farm in 1995, the concept of a petting zoo was greatly enhanced. Children learn about farm life and the animals that live there.

Natch the bear started his life in Overton Park tied to a tree. In 1907, Galloway Hall was built with simple cages for the bears. Soon, a row of outdoor pens was built, but it would not be until 1937 that the bear moats were completed, allowing more freedom for the large bears. In 2009, Teton Trek, replicating the environment of Yellowstone Park, opened, giving the grizzly bears freedom to run, swim, and dig in a large multi-acre enclosure. There is an underwater viewing areas for guests to watch the bears as they swim in a re-created stream.

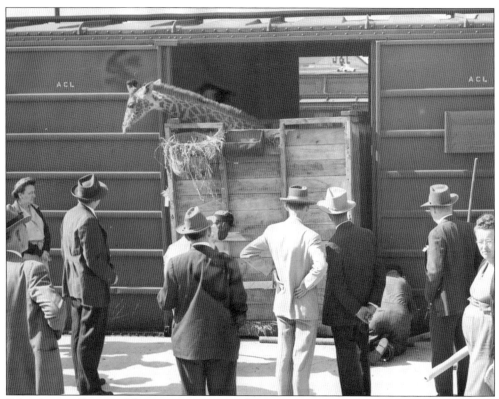

Poky the giraffe arrived by train en route to the zoo in October 1945. The Memphis Railway Express Company was used to transport many of the animals, beginning with hippos Venus and Adonis in 1914. In 1935, a baby lion "traveled from the Memphis Zoo to the Kansas City Zoo by Railway Express recently and seemed to enjoy the trip thoroughly," according to a press release from the company. In 2003, FedEx provided a plane, dubbed the *Panda Express*, to carry pandas Le Le and Ya Ya from China to Memphis. The trip made national headlines and was an example of the zoo's increasing use of corporate sponsorship.

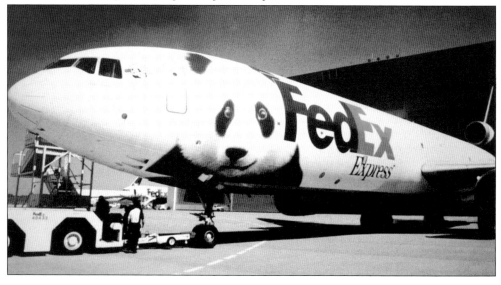

The first sea lion shows at the zoo were in the late 1930s in a simple pool located on the west side of the zoo, home to the pelicans today. With the addition of Teton Trek in 2009, a much larger and more elaborate living space was created for the sea lions. Guests can view them through large glass windows as they swim by.

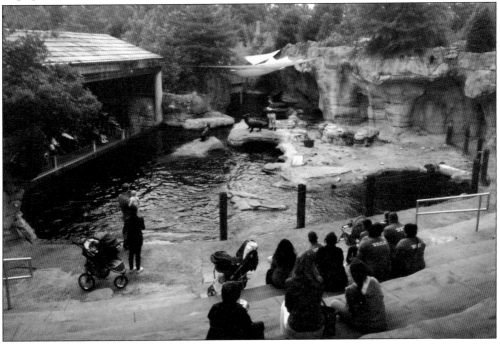

TIME LINE

1874 — First American zoo opened, in Philadelphia, Pennsylvania
1900 — Memphis Park Commission created
1905 — Baseball game held to benefit zoo
1906 — Overton Park created
1906 — Memphis Zoo established
1906 — George Horner became zoo's first superintendent
1907 — Galloway Hall built
1908 — E.K. Reitmeyer became superintendent
1909 — Carnivora building constructed
1909 — Elephant house built
1910 — Henry Loeb formed Memphis Zoological Society
1910 — Wynne Cullen promoted to superintendent
1913 — Henry W. Lewis hired as superintendent
1916 — Botanical display building opened
1922 — Orangutans Maggie and Jiggs arrived at zoo
1923 — Zoo purchased round barn from police department
1923 — N.J. Melroy hired as superintendent
1926 — Free one-ring circus began
1935 — Zoo acquired six Galapagos turtles
1936 — Monkey Island built by WPA
1936 — Chimps Popeye and Olive Oyl arrived at zoo
1936 — Virginia Brennan designed new entrance
1936 — The zoo's animal population reached 1,000
1937 — The zoo had 11 employees
1938 — Barless bear pits constructed
1938 — Lioness Queen Mary passed away at age 24
1943 — Kiddie Land opened
1943 — Victory Garden established for zoo animals
1944 — Crump Steamer fire truck brought to zoo
1946 — Florence the elephant passes away at the age of 35
1951 — Modoc the elephant arrived
1953 — Raymond Gray hired as director
1955 — Alberta Lowrance became first female zoo keeper
1955 — First freestanding zoo office building completed
1957 — Elvis donated wallaby to the zoo
1959 — Aquarium completed
1959 — May the giraffe arrived from Chicago

1960 — Memphis Zoo became desegregated
1963 — Modoc the elephant went to Hollywood
1964 — Robert Mattlin hired as director
1967 — Primate house completed
1968 — Zoo first charged admission, 50¢ for adults
1969 — African Veldt opened
1971 — Herpetarium built
1972 — Donna and Kay Fisher formed Zoo Action Program
1972 — 1909 Pachyderm building used as hay barn
1972 — Admission is 75¢ for adults and 25¢ for children
1973 — Joel Wallach hired as director
1975 — Tropical bird house received $65,000 renovation
1976 — Charles Wilson hired as director
1977 — Officially called Memphis Zoo and Aquarium
1979 — Major renovations to aquarium
1979 — Wrought iron gates added to entrance
1985 — Koala Kaper exhibit opened
1986 — First master plan created
1987 — Giant panda Xiu Hua drew 240,000 people in five weeks
1989 — Roger Knox hired as CEO
1989 — $33 million renovation began
1990 — New Egyptian-themed entrance created
1993 — Commercial Appeal Cat Country opened
1994 — Nonprofit Memphis Zoo Inc. began management of zoo
1994 — Carnivora building retrofitted to Cat House Café
1995 — Animals of the Night opened in old primate house
1995 — Once Upon a Farm opened
1995 — Primate Canyon opened
1998 — Dragons Lair opened
1998 — New animal hospital opened
2001 — Dr. Chuck Brady hired as director
2003 — China exhibit opened, featuring two giant pandas
2003 — Dr. Chuck Brady became CEO
2006 — Northwest Passage opened
2009 — Birds and Bees exhibit opened
2009 — Teton Trek opened
2009 — On March 17, the zoo had a record 20,450 visitors
2016 — Zambezi River Hippo Camp opens

DISCOVER THOUSANDS OF LOCAL HISTORY BOOKS FEATURING MILLIONS OF VINTAGE IMAGES

Arcadia Publishing, the leading local history publisher in the United States, is committed to making history accessible and meaningful through publishing books that celebrate and preserve the heritage of America's people and places.

Find more books like this at
www.arcadiapublishing.com

Search for your hometown history, your old stomping grounds, and even your favorite sports team.

Consistent with our mission to preserve history on a local level, this book was printed in South Carolina on American-made paper and manufactured entirely in the United States. Products carrying the accredited Forest Stewardship Council (FSC) label are printed on 100 percent FSC-certified paper.

MADE IN THE USA